Images of Modern America

MARDI GRAS
IN KODACHROME

D1225275

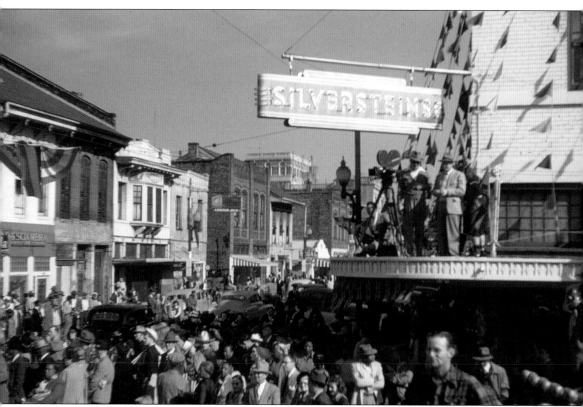

Ruth Ketcham photographed a motion-picture camera crew shooting the Mardi Gras of 1950 at the intersection of Rampart and Poydras Streets. Their enviable perch was under the signage of Sam Silverstein's Department Store, a long-running French Quarter shopping experience. Eponymous merchant Silverstein died in 1948; the store, though it remained in the family, only survived until 1954. In the Vieux Carre, a rueful phrase developed—"Ain't dere no more" (sometimes acronymized to the slightly more grammatically correct ATNM)—that describes fondly recalled but bygone local institutions. Like the grand Carnivals of the past, they now survive in memories, vintage postcards, antique-store labels, and ephemera—and in photographs.

FRONT COVER: Sometimes anchored to current events and personalities and sometimes unfettered by any theme but their own imagination (or whatever was available from the costume shops of Bourbon Street), Mardi Gras masqueraders filled Ruth Ketcham's Kodachrome slide film with an infinite variety of colors. Ketcham photographed this golden man in 1954 (Author's collection; see page 58).

UPPER BACK COVER: Most Mardi Gras parades carry a theme (some even have a storyline). This one, created by longtime Mardi Gras float/costume designer Léda Plauche, is a rendering of the state of Illinois (Author's collection; see page 45).

LOWER BACK COVER (from left to right): The grinning face of a Mardi Gras icon, a prominent Rex Krewe parade float, leads the procession in 1956 (Author's collection; see page 12); a Mardi Gras Indian cavorts in 1953 (Author's collection; see page 25); inventive costumes transform a truck krewe into living traffic lights on Rampart Street in 1954 (Author's collection; see page 65).

Images of Modern America

MARDI GRAS
IN KODACHROME

CHARLES CASSADY JR. AND MARY LYNN RANDALL
PHOTOGRAPH COLLECTION OF RUTH KETCHAM

ARCADIA
PUBLISHING

Published by Arcadia Publishing
Charleston, South Carolina

Printed in the United States of America

Library of Congress Control Number: 2018950309

For all general information, please contact Arcadia Publishing:
Telephone 843-853-2070
Fax 843-853-0044
E-mail sales@arcadiapublishing.com
For customer service and orders:
Toll-Free 1-888-313-2665

Visit us on the Internet at www.arcadiapublishing.com

*To my late "Mamo," grandmother Ruth I. Ketcham, and
my grandfather, F.M. (Ted) Ketcham, who would be so
proud of this book showcasing Ruth's photographic ability.
They would be so gratified. —Mary Lynn Randall*

CONTENTS

ACKNOWLEDGMENTS

We would like to say *merci beaucoup* to the individuals who were "first-line marchers" in helping make this book a reality, especially "Mister Mardi Gras," the celebration's great modern observer/historian Arthur Hardy, for his insights and generosity. Thanks also to Dr. Stephen Hales for Rex Krewe background, and especially Glenda and Billy Dufreche for family matters. Thanks also to Ruth Randall Hoch and Louis Burton Randall. We are also grateful to John Burton Ketcham Jr., Kathryn Ketcham Timmer, Esther Ketcham Visser, and Sharon Ketcham Cardosa (Michigan); Jerry Johnston and Guy Johnston Jr. (Delaware); and Patricia Perkins, William R. Perkins Jr., David Perkins, Glenda Dufreche, William Dufreche, Daniel Dufreche, John Dufreche, Scott Dufreche, and Thomas Dufreche (Louisiana). In memoriam, we salute the late William Hardey Randall III, Edward Dufreche, and Julian Dufreche. Further thanks must go to Lucy McKernan, Jay Hendrickson, and David Johnson. And, of course, we must express endless gratitude to our editors at Arcadia Publishing, Erin Vosgien, Angel Hisnanick, and Sara Miller, for believing in and guiding the project so that, like a krewe parade float, it could finally "roll." Finally, enough cannot be said of Mary Lynn Randall, owner of all the images presented within this book, who curated the 35mm transparencies in a blue-and-white Smith Victor metal slide box until they could, at last, be presented.

INTRODUCTION

When Ruth Ketcham died in Delaware in 1981 at age 84, she left behind a lifetime of memories not only among family members spread from Ohio, Michigan, Maryland, and Delaware to Louisiana, but caches of photograph albums, prints, and metal boxes holding 35mm slides. Ruth was the family photographer—her granddaughter Mary Lynn Randall remembers her taking countless family portraits, peering down into the smokestack-like, waist-level viewfinder of a vintage Graflex Reflex. Children in the family would tend to hide from Ruth out of fear of the lengthy posed-portrait sessions.

Ruth, however, was seldom published during her lifetime; some of those family portraits appeared in the local *Delaware Digest* when those same family children, now grown, achieved academic or career success. But she nonetheless shot countless pictures, and she belonged to camera clubs across the country. Ruth preserved a remarkable, weird, wonderful, surreal, lost world through her lenses, including New Orleans, Louisiana, at Mardi Gras in a previous generation.

Ruth was born in 1897 to the Ibberson family in Alexandria, Minnesota, near Minneapolis. She was adventurous and athletic, swimming, playing baseball (and football), hunting, and fishing. At age 26, she was lauded in newspapers as a "heroine" for rescuing a drowning girl from Lake Minnetonka, reviving the teenager after 30 minutes of lifesaving respiration. "Someone ought to see that she gets proper recognition," said one witness quoted in a local newspaper item.

When Ruth wed F.M. "Ted" Ketcham, she also married into a noteworthy household in Michigan; his grandmother, Emily Burton Ketcham, was a close friend of Susan B. Anthony (Emily was inducted into the Michigan Women's Hall of Fame for leading the suffragette movement). Ted was a successful designer of horse-racing tracks. He traveled from coast to coast supervising and planning layouts at fairgrounds and racing arenas in the United States and Canada. Ruth and Ted's two daughters, Suzanne and Nancy, went along on his voyages in a caravan-trailer. This began her love of photography.

Crossing the landscape allowed Ruth membership in photography clubs in different states. She snapped pictures in numerous formats and genres, exploring subjects ranging from church interiors to plantation exteriors to floral close-ups.

The Ketchams wintered in Louisiana so Ted could work on Southern tracks and Ruth could visit her sisters Ethel and Mary Ann in Hammond, Louisiana. For roughly 10 years, from the early 1950s to the 1960s, Ruth photographed the Crescent City's Mardi Gras in full color using Kodachrome slide film, which the Eastman Kodak Company created in 1935. Most photographers of that era, professional and amateur, favored the prevalent black-and-white negative film instead.

The 1950s became an eventful decade for Mardi Gras in New Orleans for reasons other than Eastman Kodak chemists manufacturing a diversity of film able to capture its many colors.

Carnival affairs were on an upswing. During the Great Depression, funding for the city's signature celebration had dwindled; it was later said that financing Mardi Gras depleted allocations for essential city services. Estimates are that up to 75 percent of businessmen resigned positions in the old-line Mardi Gras krewes as economic matters gained importance over gaiety. But it took the austerity, rationing programs, and urgent priorities of World War II to suspend Mardi Gras entirely for half of the 1940s—the only time that had happened other than during World War I and the Civil War (Mardi Gras also went on hiatus in 1951, during the Korean War).

Generally, however, the postwar economic boom of the 1950s meant largesse for the tradition. Mardi Gras enjoyed exposure in the eyes of the rest of the nation via mass media, glimpses (even monochrome ones) of the parades, and the krewes and grand balls. The 1930s heralded the first national radio broadcasts of Mardi Gras. By 1949, television broadcasts followed. In the late 1940s, Blaine Kern began the eponymous studio that would (and still does) construct and maintain extraordinary parade floats filling the movie-house newsreels and living-room screens.

New Orleans native Louis "Satchmo" Armstrong returned to the Crescent City and reigned at Carnival as King of the Zulus in 1949. This made the cover of *Time*. International headlines recorded the pageantry as England's Duke and Duchess of Windsor visited Mardi Gras in 1950, bowing to the Rex King and attending the Comus Ball.

Abbott and Costello Go to Mars (1953) presented an amusing embedded promo for Mardi Gras. A Mars-bound rocket ship veers off course and lands in New Orleans. In their spacesuits, bewildered Bud Abbott and Lou Costello fit right in, while the Mardi Gras marchers are mistaken for aliens—an apt metaphor for the allure and exoticism of Carnival in the mainstream United States.

While more Americans made the trip to Mardi Gras, a brash statement had been made by some reporters that as much as the Crescent City welcomed—or even needed—tourists, it really did not matter if anyone outside of New Orleans took part. This was the city's own celebration made up of its own people and unique rituals, partying in their way and observing their own codes.

Spring "carnivals" and masked balls were an ancient European tradition imported by early French colonial settlers throughout the Louisiana territory. The peculiar rituals of New Orleans solidified with the first formation of the Mardi Gras krewes in the 1850s (partially modeled after the Cowbellians, a society that had operated the Mardi Gras in Mobile, Alabama). In 1856, the Mistick Krewe of Comus pioneered traditions of Shrove Tuesday procession floats, names borrowed from Greek myths, and elegant debutante balls linked to the Mardi Gras.

Much lore surrounds a 1872 visit to New Orleans during Carnival season by the Russian Grand Duke Alexis Romanoff as having practically created Mardi Gras, as many of the customs observed to this day were established for the benefit of the foreign VIP. Historian Arthur Hardy feels this royal visit has been heavily romanticized, if not outright exaggerated, in terms of lasting influence, but it coincided with the emergence of Carnival perennials: Rex, the King of Carnival, and the debut of the Knights of Momus.

The Krewe of Proteus started in 1882, the Original Illinois Club—the first black krewe—in 1894, and Les Mysterieuses—the first all-female krewe—in 1896. They derived from social clubs, brotherhoods of Confederate veterans, business guilds, and even burial-insurance associations tied to different ethnicities and faiths. They were not necessarily beholden to anyone outside the town. It would be related with amusement, according to an article in the *New Yorker*, whenever some stranger with deep pockets and connections came to New Orleans expecting to lead a parade or even sit on the throne of Rex himself only to get a cold shoulder.

What would Ruth Ketcham have seen and heard at one of her Mardi Gras adventures that would have been distinct from today?

Essentials would have been the same. Lundi Gras, or "Fat Monday," was missing a prominent feature. It had been the fashion for the King of the Krewe of Rex—an eminent krewe composed of high officials and business leaders—to be ferried downriver by boat to the foot of Canal Street (to be greeted by the King of Zulu) and read a proclamation officially opening Mardi Gras celebrations. This wonderful spectacle was curtailed in the years that the United States became embroiled in the First World War, and it did not resume on any regular basis until it was reinstituted in 1987.

During the parade, an invitation summons Rex to pay respects at the grand ball of the Krewe of Comus, the oldest of all krewes; its membership includes great families of the town. There is symbolism here in the partnerships of New Orleans' community: Rex represents the civic/business leaders; Comus, the aristocracy; and the riotous Zulus, the city's colored working class.

Parading would begin through the French Quarter in the early hours of Tuesday (many of the old French Quarter routes were changed late in the 20th century due to the narrowness of the streets). Ruth could have followed one of several routes and vantages, with Bourbon Street, St.

Charles Avenue, and Canal Street among the most trampled of the thoroughfares. (Mardi Gras is an official state holiday in Louisiana; even streetcars would cease running.) Costumed krewes, on foot or "rolling" on floats, would be cheered on their journeys down the boulevards.

Major krewes such as Rex and Comus would be certain to pass the grandstand of the aristocratic Boston Club; others would pass the city hall. There would also be "first line" and "second line" marching societies and bands. Following, accompanying, and spectating would be the large crowds of working-class folk, sometimes called "Yats," a reference to the standard greeting "Where y'at?"

In exchange for some financial reimbursement from saloons and eateries along the route, a krewe might halt its procession at a certain address to take a break—providing an uptick in business for the bar as spectators loitered. This scheme helped the Zulus, especially with raising money for expenses.

The customary call—"throw me something, mister!"—would bring the "throws" from the floats resulting in showers of treats, toys, dolls, cups, wooden nickels, and small trinkets. The 1950s saw the introduction of aluminum "doubloon" souvenir coins formulated by H. Alvin Sharp for the Rex organization and stamped with the likeness of King Rex. The story states that Sharp's initial aluminum doubloons were literally timeless, with no year stamped on them. In the event that doubloon-throwing proved to be unpopular, the surplus doubloons could then have been reused the next year (and the year after that) until the treasury was depleted.

It was less appreciated by casual tourists that at least one group in the Mardi Gras parade expected things to be thrown at them. These were the flambeaux, or ceremonial torch-carriers, customarily from the black populace, who marched alongside the pageant of Rex, Comus, and other old-line Mardi Gras kings and krewes en route to their grand balls at night, usually on Fat Monday. In gratitude for this service in lighting the way, etiquette dictated that onlookers would see to it that their paths would be strewn with coins—not doubloons but honest pocket change, real spending money.

While multicolored giveaway bead necklaces were a longstanding component of Mardi Gras, in the 1950s, the jewelry was made of glass. Production of lightweight, cheap plastic necklaces in the early 1960s made Mardi Gras beads ubiquitous in Carnival antics. Along with the more versatile beads, plastic, silver, and bronze doubloons came into primacy, with many minted to advertise local businesses and institutions. Today, genuine pre-1960 Mardi Gras doubloons are prized among numismatists.

Among the oldest and most famous throws were coconuts hurled from the floats carrying the Zulu King and his entourage. One could well imagine the hazards involved in heaving coconuts at crowds of revelers. Even Louis Armstrong, recalling his illustrious reign as the King of Zulu, said one particular celebrant called upon Satchmo to throw him a coconut. Armstrong sent a heavy coconut sailing; it bounced off the man's fingers and smashed into someone's nice, shiny Cadillac. Armstrong called the incident "a close shave." Later, injuries and lawsuits would bring about coconut reform.

During the 1950s, the civil rights movement opposed the very existence of the blackface-painted Zulu Krewe. Yet they persisted as favorites among both black and white residents. During the 1955 parade, a Zulu King named Nathan King tried to appease critics by parading minus the iconic blackface makeup (other Zulus kept persuading him to put the greasepaint back on, though). During the 1960s, threats of activist boycotts reduced the number of Zulu Social Aid & Pleasure Club members until it hit a low of 15 men in 1965. Yet, with the efforts of the faithful and remodeled Zulu imagery, the krewe defiantly persisted.

Almost as eyebrow-raising as the Zulus are the Mardi Gras Indians, one of the various marching societies. Also composed of black citizens, they wear enormous, variegated feather-laden costumes that take months to create. In an intricate choreography of "chiefs," "spyboys," and others ranked in individual tribes, each Indian krewe would try to outdo the others. Then there were the Baby Dolls, traceable to marching groups of black prostitutes from the Storyville era of legalized prostitution in the Vieux Carre. The Baby Doll tradition continued, often with face paint that would do a Japanese kabuki show proud, still saucy but with a more stylized and refined attitude.

As the Zulu, Indian, and Baby Doll krewes danced across the racial boundaries of the 1950s, the Mardi Gras drag queens did the same with gender barriers in that conservative decade.

Some of the cross-dressers during Carnival might be rambunctious, heterosexual college boys at play or otherwise straight-laced businessman comically attired as women, something they might do for a guild "stunt nite." But for serious cross-dressers, Mardi Gras was a rare haven in the 1950s in which they could publicly parade in full wardrobe and makeup and be accepted—more or less. Some journalists recorded that cross-dressers might be assaulted by flung beer cans and bottles. In 1958, local gay men formed the Krewe of Yuga, the first openly homosexual krewe, but repeated police raids on their masked balls led to the disbanding of Yuga in 1962. When a second gay krewe, Petronius, organized, founders received a state charter to prevent harassment from officials.

In the 1960s, restaurateur Arthur Jacobs initiated a cross-dressing costume contest, ostensibly to draw throngs to The Clover Grill, his place at the intersection of Bourbon and Dumaine Streets. The novelty evolved into the Mardi Gras Bourbon Street Awards, a roving competitive drag-vogue tournament that became a centerpiece for the city's gay subculture.

Outsiders in 1950s New Orleans may or may not have appreciated the behind-the-scenes politics and symbolism. Perhaps, like a bewildered Lou Costello, they may have felt they had stepped from Eisenhower's planet into another universe, an adult Seussian world of Rex, Comus, Momus, Zulus, Indians, Yats, Baby Dolls, cross-dressers, and unclassifiables, all there for *les bon temps*.

For those lacking the ways and means to travel to New Orleans during the 1950s Mardi Gras celebrations, Ruth Ketcham's camera presents precious moments in full, vivid Kodachrome, of which Paul Simon sang, "Give us the niiiiiice, bright colors." Like many proud photographers of the film era, she presented these pictures to audiences in projected slide-show form, likely narrating the shows herself. But the publication of her images had never happened—until now.

Ruth Ketcham's Mardi Gras Kodachrome photographs revive a bygone (and yet, every February, continuing) era in New Orleans French Quarter history and fulfill what a Minnesota newspaper once printed: "Someone ought to see that she gets proper recognition."

One

FIRST LINE

REX, ZULUS, PROTEUS, BABY DOLLS, AND STORMY

A teenage Ruth Ibberson posed for a traditional debutante-style studio portrait around 1917. Even in the 1950s, black-and-white film was the default for both amateur and professional photographers and lab services. But as early as 1949, Ruth was shooting color transparencies and using a process originally called AnscoColor (later AnscoChrome); the next year, she started a decade-long Carnival affair with Kodak's Kodachrome. Though far more chemically stable (Ruth's old AnscoColor slides have faded so severely that they are nearly monochrome today), Kodachrome did pose challenges. It needed long, precise exposures and/or bright light for proper images. Thus, fast-moving subjects (like krewe strollers) tended to blur. No family members recall Ruth using a tripod or high-end equipment. Nonetheless, she must have been infatuated with this film. And 1950s Kodachrome (with higher silver content than later formulations, hence richer colors) was a match made in heaven for the Mardi Gras rainbow.

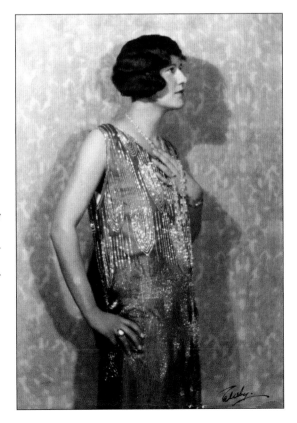

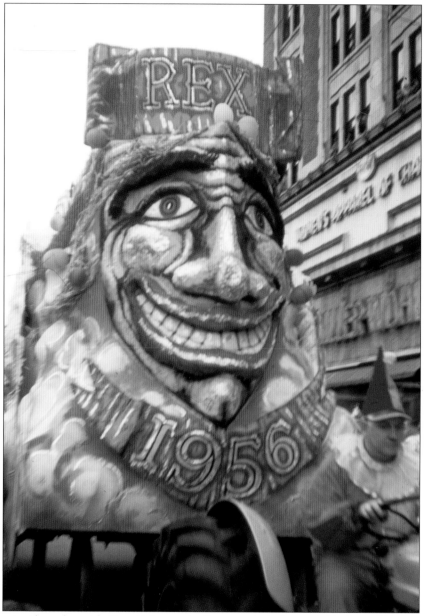

To many inside and outside New Orleans, the Rex parade is the veritable face of Carnival. The dazzling lead float of the Rex Krewe, founded in 1872, here "rolls" at the start of a procession in 1956. Parading krewes typically center their float designs around a theme, and some early ones—particularly those chosen by the satirical Knights of Momus—were notorious for biting caricatures and political humor in their tableaux. But over the long term, parade themes have been noncontroversial, and the one for the 1956 Rex parade was "Festivals Around the World." A large number of Mardi Gras floats were designed and/or manufactured by Blaine Kern Artists, a company founded in 1947 that still continues to this day (as Kern Studios). As many as 90 percent of the parading krewe floats seen in a New Orleans Carnival procession are now Kern creations, with some costing as much as $250,000 apiece (thus, smaller krewes now tend to rent rather than own their Kern floats).

A Rex parade float of 1953 loudly advertises itself. The letters in the "REX" are color-coded in the official symbolic hues of a New Orleans Mardi Gras: gold for power, green for faith, and purple for justice, and that theme frequently recurs in beads and costumes, such as the harlequin-style merrymaker at right, who is highlighted with Kodachrome's optimum vibrancy during a bright, sunny Mardi Gras in 1954.

The Krewe of Proteus is, after Rex, the second-oldest of the New Orleans Mardi Gras parading krewes. Proteus is a shapeshifting god of Greek mythology, subject to Poseidon. Hence, nautical elements and fanciful marine life tend to typify a Proteus float, as with this 1954 specimen, part of a larger procession with the theme "Proteus Through the Years."

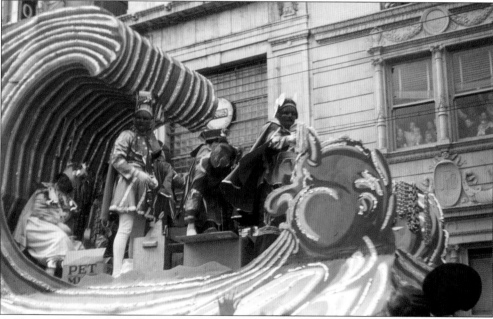

A Krewe of Proteus float illustrates Aeolus, King of the Winds, in 1953. Note the beads being handled and draped at the fore in the years before lightweight plastic beads came into vogue. It was a prudent strategy to avoid tossing glass beads for any distance and just hand them out to lucky recipients whenever possible. The 1950s were the decade during which beads were introduced in the Mardi Gras parades. When domestic beads proved too costly, cheaper ones were imported from Czechoslovakia. Then, even more cost-effective, tube-shaped glass "bugle beads" from Japan enjoyed popularity. It was not until the 1960s that plastic beads came into play and increased the popularity (and safety) of this emblematic Mardi Gras jewelry. They also came in all possible colors.

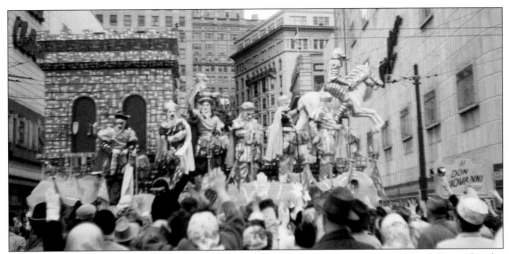

"Don Giovanni" was the theme of this float ridden in the 1958 parade on Canal Street by the Babylon Krewe, who drew opera as their overall flavor that year. Also known as the Knights of Babylon and initially called the Jesters Club, Babylon formed in 1939 and gained a reputation for first-rate floats and ballroom tableaux. Babylon traditionally marches on the evening of the Thursday before Mardi Gras Tuesday; adherents state that Babylon literally opens the festivities. Babylon's carnival king has always been named Sargon; his civilian identity is a closely guarded secret.

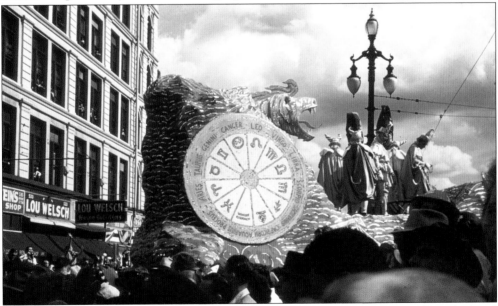

A float endowed by eminent designer Léda Plauche with a zodiac motif passes through Canal Street in the Rex parade of 1950 ("Adventures in Slumberland"). Judging by the spectators at left, a throw was in progress. Even decades later, it is a point of pride for original "old-line" krewes to still have floats created with as much traditional all-timber construction as possible. Foundations of typical floats used in the 1950s were caissons specially built for the processions, and though pulled by tractors, many dated back to the horse-and-buggy days of the previous century. Older floats were nothing fancier than archaic cotton wagons originally pulled by mule trains. Though often unseen by spectators, the wooden chassis of the most famous old-line krewes are painted with trademark colors. Green belongs to Rex, red to Proteus, and blue to Momus.

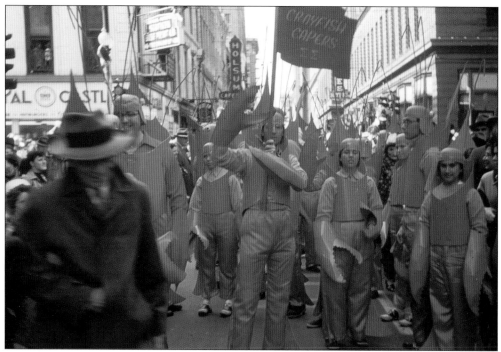

These were the eye-catching red costumes of "Crayfish Capers," a walking club display in 1953. Walking (or marching) clubs had long been a fixture of Mardi Gras dating back to semi-informal men's clubs in the 19th century in uptown New Orleans. The Jefferson City Buzzards, formally incorporated in 1890, is the oldest surviving specimen. Although frequently overshadowed by the larger parading krewes (who can "host" the walking clubs in their processions), a walking club can put on an amazing spectacle by themselves.

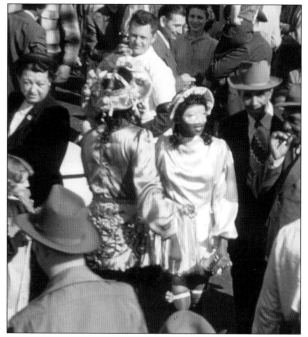

In a sea of revelers on South Rampart Street in 1950, Ruth Ketcham's lens found a pair of satin-clad followers of the Zulu krewe attired in Baby Doll fashion. Traceable to the days of Storyville, a legal prostitution zone in parts of the French Quarter created by a municipal ordinance, the Baby Dolls started with groups of black prostitutes boldly marching in Basin Street for Mardi Gras in 1910 in their most provocative finery. Although Storyville was abolished in 1917, the Baby Doll tradition continued (and continues) with first- and second-line marchers in distinctive outfits, masks, and mime-like face paint—the African American community's women flaunting an unbowed, fun-loving "bad girl" image of bygone years.

The Boston Club is a New Orleans institution dating back to the early 1840s that came to play a vital role in Mardi Gras. During parades of old-line krewes, organizations such as Rex and Momus would have their kings toast the queen, watching from the Boston Club's reviewing stand (here, the Rex Queen is Patricia Henican in 1956). The club had no direct association with the city of Boston but rather evolved from regular meetings of card-players who fancied the French-derived card game Boston de Fountainebleu (similar to whist). Over the years, many prominent Orleanians would become members of the Boston Club, which took up a longstanding residence in Canal Street. Other krewe parades chose to pay their respects in similar toasting rituals at city hall.

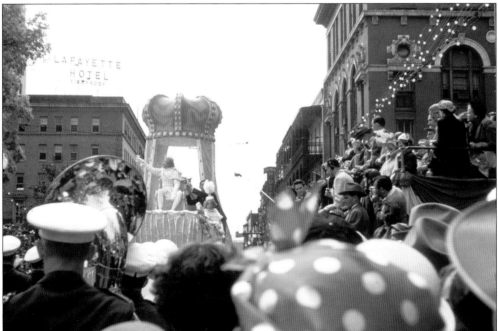

The highlight of the Rex parade is a public toast during which the Rex King traditionally praises local individuals, institutions, and charitable causes. Here, the Rex King of 1954, Leon Irwin Jr., does the honors while surrounded by a sea of revelers and even more loyal subjects listening on the local airwaves as a broadcast news reporter holds out a microphone. (Irwin was a second-generation Rex King; his father had held the office in 1928.)

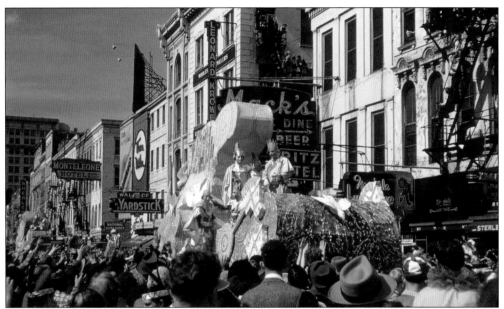

The theme of the Rex parade of 1950 was "Adventures in Slumberland," here borne out in a 20-strong line of floats down Canal Street. When not in use, the giant floats are stored in warehouses known as "dens." In keeping with the exclusivity of the social clubs behind the krewes, the location of such dens was a closely guarded secret, though most of them, it was commonly known, were on Calliope Street. On December 4, 1950, a fire, apparently started by vagrants in an empty house on Magnolia Street, spread to nearby Calliope Street and the Rex den. Decades of records, precious costumes, and 20 Rex parade floats were incinerated in the blaze. In the aftermath, the Knights of Momus and the Krewe of Proteus generously offered the Rex organization loans of costumes and floats for the upcoming 1951 Mardi Gras. But an even greater disaster—the Korean War —and Pres. Harry Truman's declaration of a national emergency persuaded the krewes to suspend Mardi Gras that year. Up until the mid-1950s, many float designs (as well as the more elaborate costumes), especially for the Rex Organization, could be credited to Léda Plauche (1886–1980), who rendered her artistic services to the krewes of Momus, Comus, and Proteus.

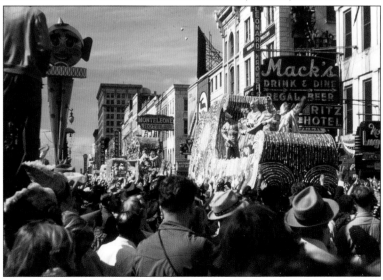

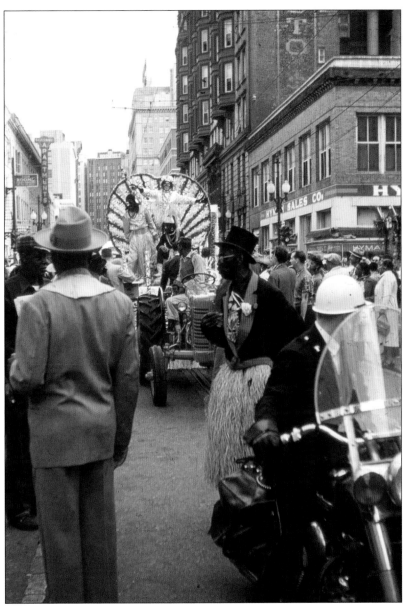

After the Rex parade, Ruth Ketcham's favorite krewe seemed to be the Zulus. Mardi Gras Zulus incorporated their first krewe in 1909 and established the best known, the Zulu Social Aid & Pleasure Club, in 1916. They were immediately immensely popular. Wearing darkened faces and grass skirts, Zulus burlesqued the mighty Rex King, who would arrive in a formal boat (first a riverboat and, later, a Coast Guard ship). The Zulu King would land in a "royal yacht" that was typically a rusty barge or tug. Joining the king would be the Queen of Zulu, the Witch Doctor, and a character on a competing float, the "Big Shot of Africa." To some eyes, the Zulus embodied minstrel-show racist stereotypes. To others, the proud Mardi Gras Zulus (leaders hailing from diverse walks of black society) came from the ancient custom of clowns and jesters mocking the pompous pretension of their alleged "superiors" and getting away with it. King Rex and King Zulu paying their respects to each other is a more-than-symbolic Mardi Gras ritual reflecting the multicultural makeup of the city.

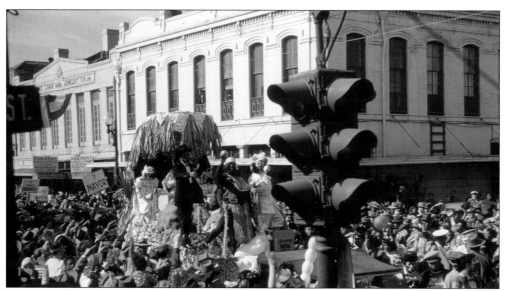

The Zulu float is shown here on South Rampart Street in 1950, its occupants poised to hurl Zulu coconuts into the crowds. It is no wonder that Ruth Ketcham stood at a distance to take this picture; damage to people and property (and resulting lawsuits and heightened insurance rates) inflicted by the pound-and-a-half Zulu throws was such that, by 1985, a law threatened to ban them altogether. A special 1987 "Coconut Bill" in the Louisiana legislature exempted the coconut and other throws from liability, but along with that came the provision that the coconuts be drained, shaved, rendered as light as possible, and gently handed out.

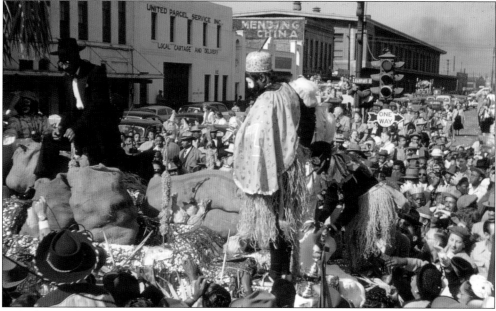

Onlookers pack the 1950 Zulu parade route at the intersections of Poydras and South Rampart Streets, eagerly anticipating the launch of the coconuts. Decorated Zulu coconuts (in the burlap sacks) came into being with the dawn of the Zulus and were the very first Mardi Gras throws—free souvenirs and commemoratives tossed out into the crowds. The original heavy, hairy Zulu coconuts are much prized and were kept as souvenirs in the Ketcham household for generations.

Floats roll in the Zulu parade of 1956. The Zulu Krewe's pageant followed a time-honored formula, with the Zulu King's float often bookended by those of other favorite characters such as the Witch Doctor, the Ambassador, and the Big Shot from Africa. Later, more characters would be added, such as Mr. Big Stuff (a rival to the Big Shot and a nod to the Jean Knight soul-music hit of the 1970s). Over time and with mounting disfavor from civil rights activists, the Zulu makeup evolved from minstrel-show/Al Jolson blackface into more abstract, asymmetrical, and stylized designs not far removed from authentic African tribal adornments. Some Zulus show just such faces here. As criticism of the Zulu tradition grew out of the civil rights movement, *New Yorker* magazine journalist Calvin Trillin, a longtime Mardi Gras observer, covered the controversy. One organizer told him he knew well that the costumes (inspired by a popular 1909 vaudeville sketch) had grass skirts that echoed Hawaii, the coconuts South America, and the leopard skins and tooth necklaces Africa. Rather than being racist, said Trillin, the whole idea was not only to be ridiculous but globally ridiculous, as befitting New Orleans' international character.

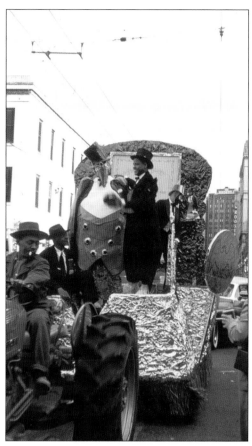

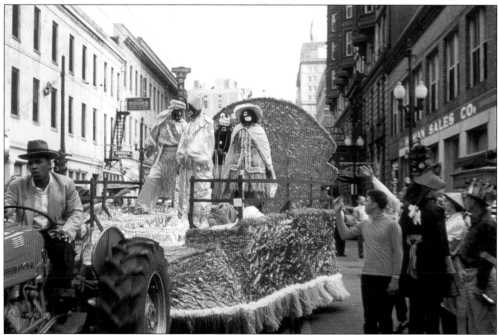

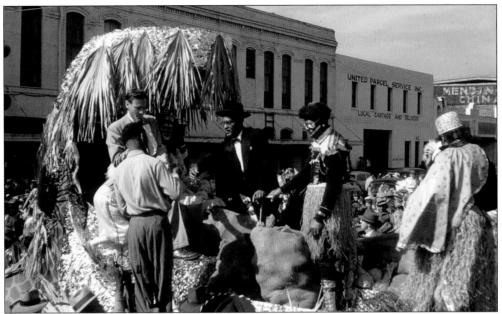

In a mirror of the Rex parade, a highlight moment of the Zulu Social Aid & Pleasure Club parade is the pouring of the official toast, shown here at South Rampart and Poydras Streets in 1950, with a radio broadcast crew in attendance to record the words of Zulu King William Poole. Poole had the honor of succeeding the great Louis Armstrong, whose portrait as King Zulu of 1949 made the cover of *Time* magazine.

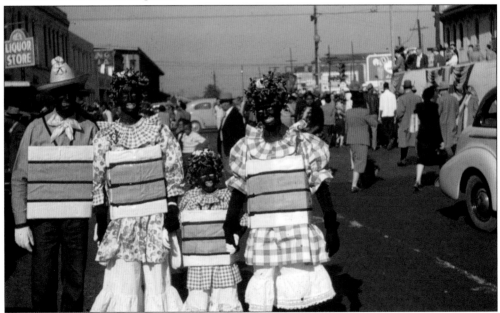

Though the blackface costuming of this 1950 quartet may be regarded as highly distasteful, one element is notable; the square shapes they wear around their torsos represent bales of cotton. Even in the 1950s, teams of African American laborers were still toiling away in the cotton fields of rural Louisiana in the same manner as they had for well over a century. This was a commonplace sight photographed by Ruth Ketcham and many others.

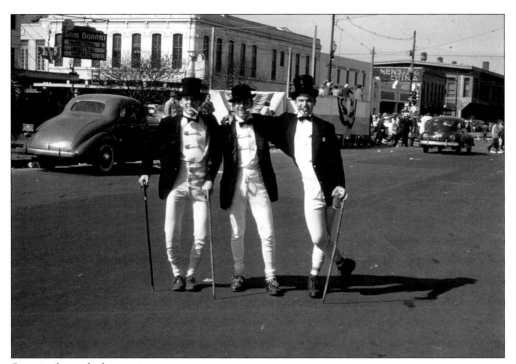

Seemingly ready for putting on the ritz in the middle of the day, a dapper 1950 trio poses on South Rampart Street.

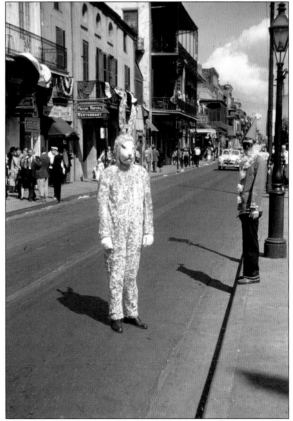

A few odd figures stand out in Royal Street during a lull in the 1950 parade. The pink structure behind the rabbit is the historic "Banque de la Louisiane," which dates to 1795 and, at one point, housed the first bank in the territory following the Louisiana Purchase. The renowned address of 417 Royal Street, which housed the Patio Royale restaurant in 1950, became, in 1956, the long-term home of the iconic Brennan's Restaurant (formerly in Bourbon Street).

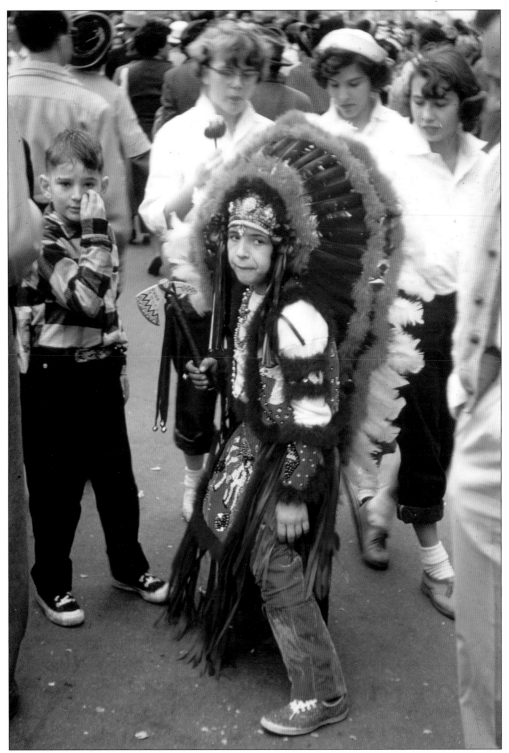

Mardi Gras Indians could be of two varieties. On one hand, many whites perambulated in elaborate mock–First Nations ensembles, such as this young lad in a colorful 1956 outfit.

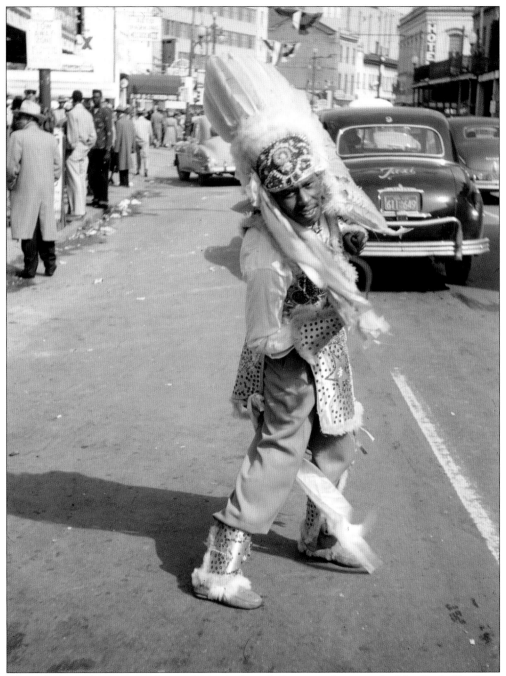

Then there is the more archetypal Mardi Gras Indian, as photographed by Ruth Ketcham here in 1953. These Mardi Gras Indians are composed of the city's black citizens. They wear enormous, original, feather-laden costumes that take months to create, and they perform intricately choreographed routines. The origins of the Mardi Gras Indians have been traced back to everything from colonial African/Native American interactions to the influence of visiting Buffalo Bill Wild West Shows in the late 19th century to ancestral memories of the Sunday African slave dances at Congo Square throughout the 1820s and 1830s.

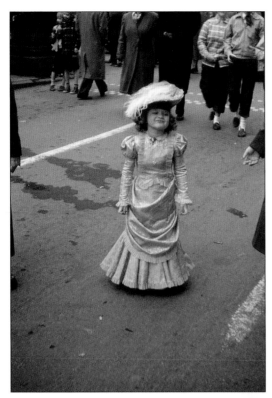

The lavender dress stands out in this portrait of a little girl bracing herself against the chill in 1952, and in 1953, a young man painted himself head to foot in the same color (hopefully contending with more hospitable temperatures).

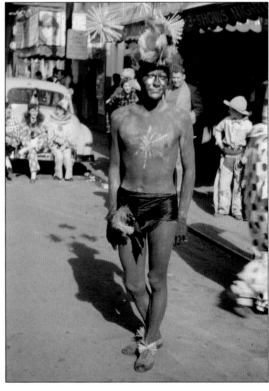

It is not generally remembered that right before the 1950s, there existed a parading krewe made up entirely of children: the Krewe of NOR (New Orleans Romance). They had their own kings and queens (elected from elementary-school ranks) who ritualistically toasted each other in Canal Street and had their own scaled-down grand ball in the evening. This little girl in a Bo Peep costume in 1953 just missed out on that era. She is succored by a vendor cart bearing Fudgi Frost, once a widespread cold treat. Below, in 1950, a little mouse, a red devil, and other children enjoy a break with refreshments provided by the Russell Polar Bar vending cart, with bars priced at only 5¢ apiece.

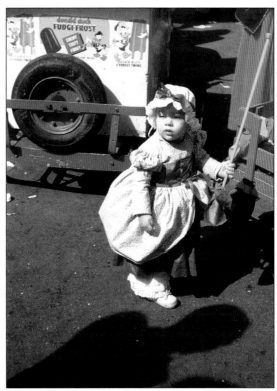

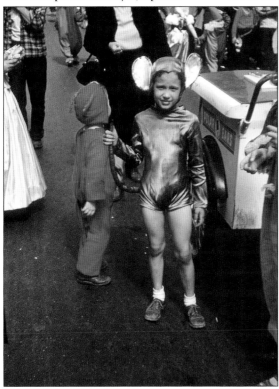

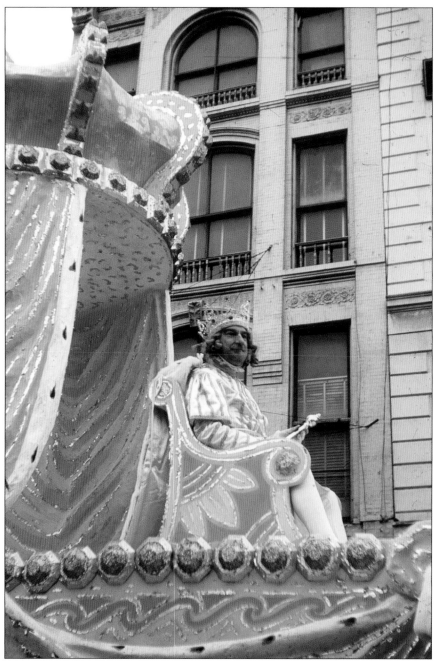

William Waller Young was Rex King in 1952. From 1955 to 1956, he served as the president of the Louisiana State Bar Association. His was a veritable carnival dynasty; his son, William Waller Young Jr., also went into law and would wear the crown of Rex, King of Carnival, in 1987. In the run-up to the Rex King making his debut every Fat Tuesday, comical "radiograms" would appear in the New Orleans newspapers in silly diplomatic-bulletin language describing the monarch's perilous international efforts to reach the city in time for the celebration and summit-type meetings with other dignitaries from fictitious Graustarkian lands along the way. The Zulus similarly had satirical storylines attached to their processions.

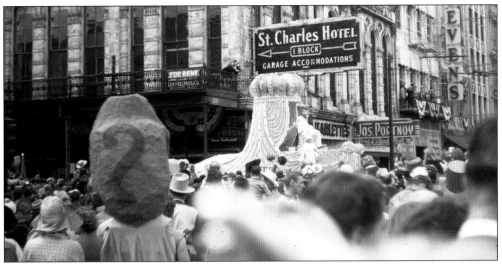

The float of the 1950 Rex parade passes by a landmark, the Original Crescent Billiard Hall in Canal Street and St. Charles Avenue. The structure, dating to 1826, was originally the Merchant's Hotel before its conversion in 1865 to "the largest billiards saloon in the world." With the genesis of the first Mardi Gras krewes, it became headquarters to the famous Mystick Krewe of Comus, and the facade saw heavy remodeling by architect Henry Howard. In the year Ruth Ketcham took this picture, the venerable Pickwick Club, one of the city's best established 19th-century social clubs (membership in which also conferred membership in Comus) moved into the first few floors of the billiard hall. The Pickwick Club resides there to this day. The Comus krewe stopped parading in 1991 but continues to hold lavish Mardi Gras balls.

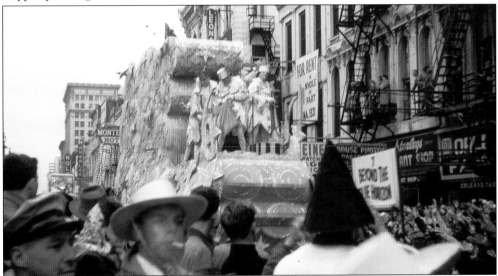

In the Rex parade of 1952, a float entitled "Beyond the Blue Horizon" rolls in Canal Street (besides being the title of a 1930 popular song, this was the name of a 1942 movie starring New Orleans native Dorothy Lamour; the glamorous actress was a special guest in the Mardi Gras festivities of 1956). Canvas and chicken-wire were key components in floats in the 1950s. In later years (and into the present day), sculpted styrofoam comprised much of the surface of the floats, but they are still covered with a layer of papier-mâché, the fundamental element of Mardi Gras—even if only to prevent solvents in modern paint from eating into the styrofoam.

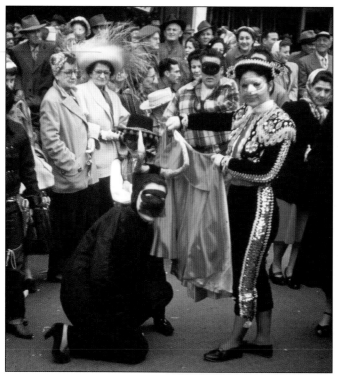

Pictured at left are a young pair dressed as bullfighter and bull in 1952, with a small caballero, presumably a relative, in the background. Looking at the shoes brings into question who might be male and female in this tableau. They were not, however, the only matadors and minotaurs photographed by Ruth Ketcham during the 1952 proceedings; below, a trio stands in Canal Street.

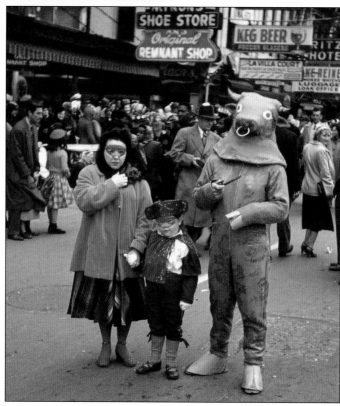

Two festivalgoers are pictured in 1952 in Canal Street with their beverage of choice—7UP. It is little known today that until 1950, 7UP's formula contained the psychotropic drug lithium citrate. Hopefully, these two did not need it.

A float of "Wee Elves" cruises Canal Street in the 1952 Rex parade, with the theme "Panorama of the Magic Sugar Egg." Being a masquer aboard a float was not the safest occupation. In his renowned history *Mardi Gras . . . As It Was*, writer Robert Tallant writes of floats collapsing and the riders (always male, except for the now-defunct, women-only Krewe of Venus) falling or even being killed during a procession. But it was also likely that a krewe member afflicted with too much cheer might drop off a float and not resurface among his cohorts until Ash Wednesday with only a hangover and a hazy recollection of what had happened.

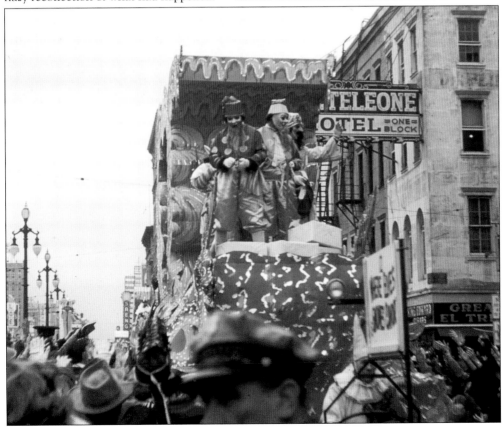

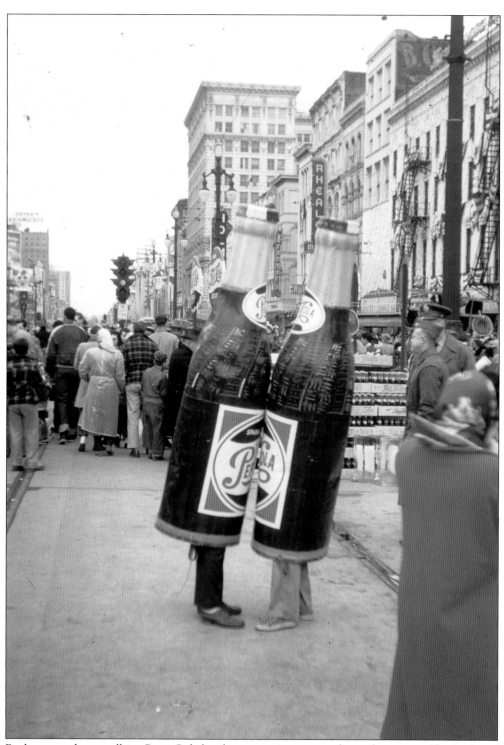

Ruth captured two walking Pepsi-Cola bottles conversing—or, perhaps, sharing a public display of affection? In any case, they were on Canal Street during the 1952 carnival. Note the servicemen in uniform at right; the Korean War had prompted the cancellation of the 1951 Mardi Gras.

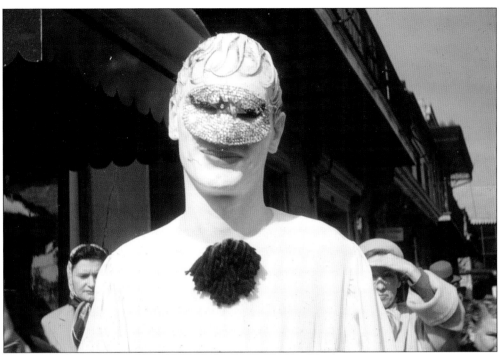

Under bright sunlight, Kodachrome could make even the color white pop out. Witness this greasepaint makeup and sequined domino mask, a smiling yet inscrutable face of the 1953 Mardi Gras. This is a portrait worthy of the famous comment by photographer Diane Arbus that, "a photograph is a secret about a secret. The more it tells you, the less you know."

This 1953 pair offer an androgynous vision in pink and green chiffon. Behind them at right is Gasper's Bar, located at 440 Bourbon Street and owned by Gasper Gulotta, variously known as "the little mayor of Bourbon Street" and "the little mayor of the French Quarter." Gasper's was a known location for gambling rackets and other illicit activities, but bartender–turned–club-owner Gulotta is accorded respect by historians for being a versatile "fixer" in the Big Easy underworld—a rough-hewn but not particularly violent character who could skillfully negotiate deals on both sides of the law to everyone's satisfaction. He upheld a degree of order in the neighborhood. Gulotta's appointment to a special citizen's investigating committee intended to clean up vice and criminality in the district's saloons met with some protests, but Mayor deLesseps Story "Chep" Morrison firmly stood by Gulotta (who had contributed to the mayor's election funds). When Gulotta died in 1957, Mayor Morrison, a police superintendent, and assorted mobsters served among the pallbearers.

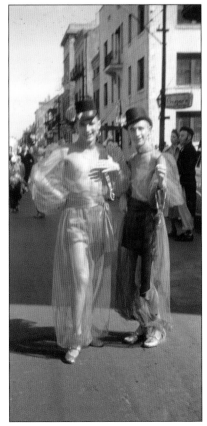

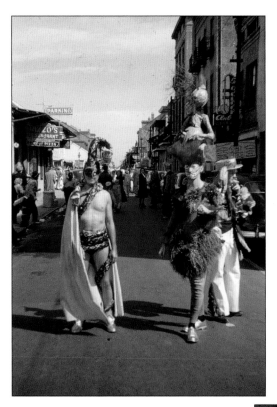

The story of the Garden of Eden has long been a Mardi Gras mainstay (a mock King Rex cameoed as Adam in a famous 1879 "History of the World" float). Cross-dressing strollers referenced the Book of Genesis in the 1953 carnival in various fashions. Here are two (or three) costumed characters in Bourbon Street. Below, a man chose an Eve-and-the-serpent motif, incorporating the whole Garden of Eden story into one costume. It may be a worthwhile footnote that a persistent fable in French Quarter folklore describes an exotic tree (usually a fig), planted by an angel, that would not bloom in fruit until the city was purged of sin. The tree never did bloom, they say. In 1954, Rev. Billy Graham held a revival at Tulane Stadium, singling out poor Bourbon Street as "a stench in the nostrils of God."

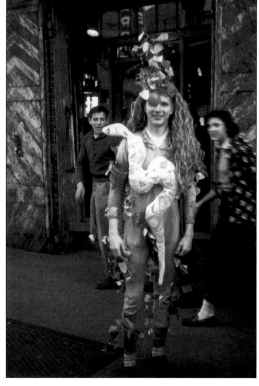

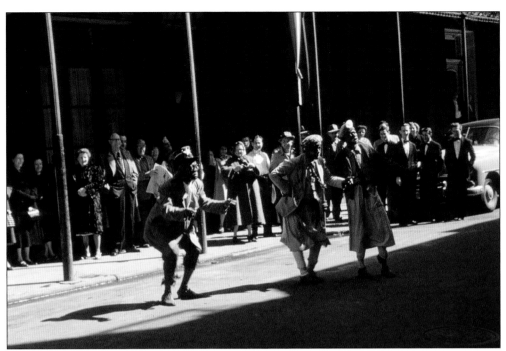

Tuxedos and an archaic minstrel-show routine blend in the sunlit street outside Antoine's Restaurant, a longstanding French Quarter tradition for fine dining, which has been owned by the same family since its 1840 founding by Antoine Alciatore. The restaurant was 113 years old when Ruth Ketcham took this photograph in February 1953.

That same year, Ruth found a different facet of French Quarter leisure as a cross-dressing mermaid capered with a sailor and a clown in front of a poster advertising Stormy. Stormy was Stacie Lawrence, a Philadelphia transplant who became one of Bourbon Street's most celebrated strippers of the 1940s and 1950s, owning a club and making rambunctious college-campus appearances. In 1952, she earned additional notoriety for promoting the presidential campaign of Alabama's Democratic governor, James "Kissin' Jim" Folsom (a politician somewhat tarnished by paternity suits and scandal). After dropping out of sight, she died in New Orleans in 1982.

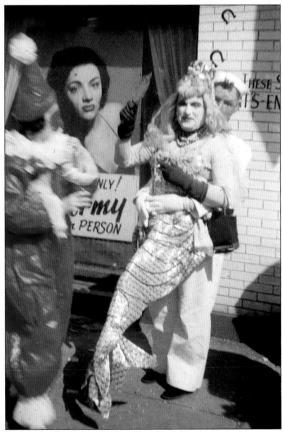

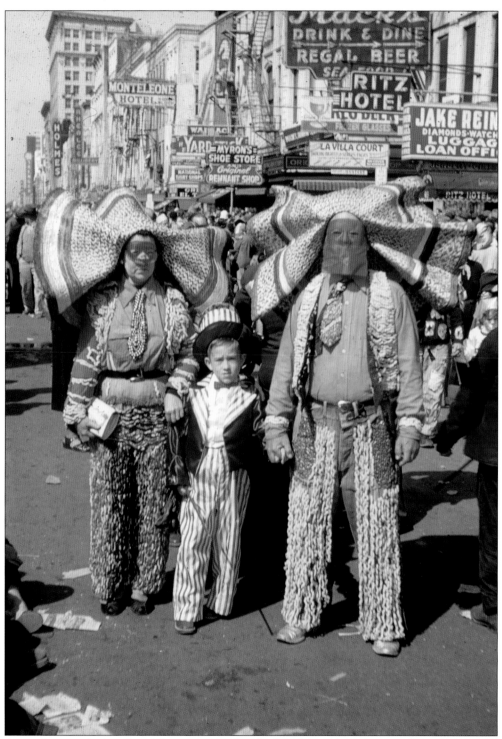

A trio photographed on Canal Street in 1953 played off the lyrics of "Yankee Doodle." The patriotic boy in the Uncle Sam costume is flanked by a pair of attendants whose elaborate costumes, as Ruth Ketcham's caption reveals, are decorated by elaborately colored bits of actual macaroni.

The onlookers of Mardi Gras parades are often as transfixing as the processions. In 1953, a spectator on a fire escape attired himself as the comic-strip costumed hero The Phantom (created in 1936 by Lee Falk), a character whose popularity took hold internationally among the Allied nations during World War II.

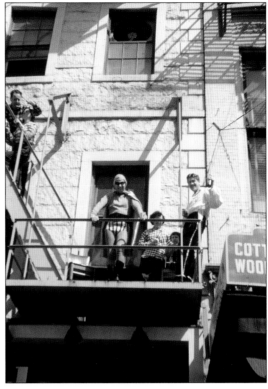

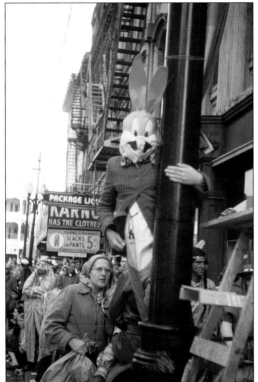

Another funny-pages spectator vies for a better view of things—or at least as good a view as the Bugs Bunny mask would permit. Bugs Bunny made his celluloid debut in 1938, and the character, said to be at least partially inspired by the mannerisms of actor Clark Gable in his early comedic roles, became an emblem of the Warner Brothers cartoon factory. In the 1950 Looney Tunes short *8 Ball Bunny*, Bugs attempted—unsuccessfully—to visit Mardi Gras.

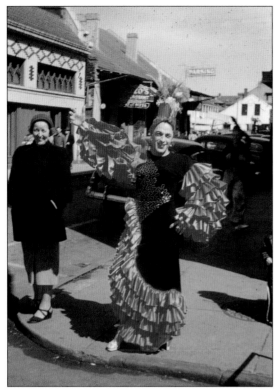

In this cross-dressing flamenco-dancer fantasy on Bourbon Street in 1953, the hat especially might be a nod to "Brazilian Bombshell" dancer/actress/comedian Carmen Miranda, a household-name entertainer whose last few Hollywood movies were released that same year. The debt to Miranda is even more apparent in the below trio photographed by Ruth in 1954. To the shock of her many fans, the iconic Miranda died suddenly the next year, in 1955, immediately following a nationwide broadcast television appearance with Jimmy Durante. She was only 46.

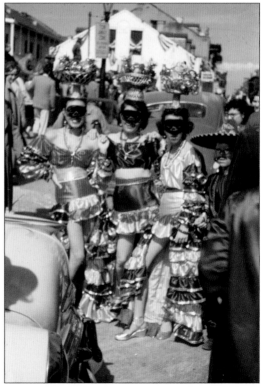

Sometimes Ruth would photograph other people taking pictures of Mardi Gras. The woman at center in this only–in–New Orleans assembly—a few pirates, a Dutch milkmaid, the Great God Pan—is wielding a Speed Graphic, a classic camera of the era that made images on precut flat sheets of four-by-five-inch film (no Kodachrome versions of the sheet film were available, either). Although the Speed Graphic was a mainstay of newspaper and professional photography for a generation, it was a difficult instrument to load and wield and gradually yielded to the smaller, easier-to-use 35mm cameras like the one Ruth used to take these pictures.

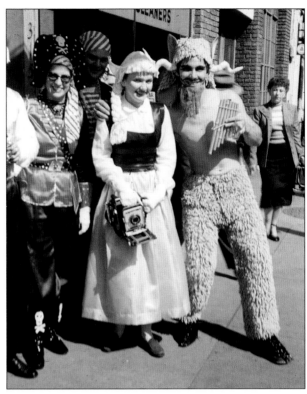

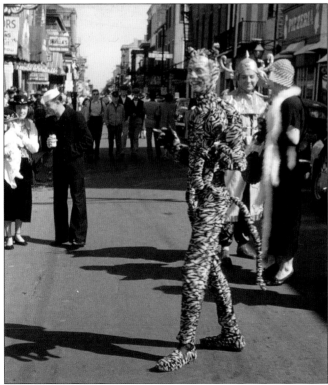

Ruth captured a tiger-striped man with his campy cohorts, a sailor (possibly a real one), and some classic French Quarter yats in the background. To the left is the shingle of the nightclub and strip bar previously known as Jimmy King's Mardi Gras Lounge. It was taken over by popular clarinet player Sid Davilla, who lent his own name to the place. In his memoirs, New Orleans historian and jazz promoter Al Rose claimed that in 1954 he persuaded Davilla to curtail seedy strip shows and devote the entertainment portion of his eponymous club purely to jazz music.

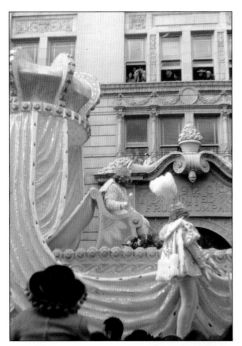

The Rex King of 1953, Charles C. Crawford, passes a Louisiana architectural landmark, the ornate doorway of the United Fruit Company building at 321 St. Charles Avenue. The famous and controversial—the company's size and influence impacted US foreign policy in Central America, especially—fruit importation corporation had its headquarters in New Orleans from 1933 to 1970. The year 1954 was a tumultuous one for the company; it was involved in political interventions in Guatemala (fated to cause decades of strife and radicalization) and charges for violations of the Sherman Antitrust Act and the Wilson Act.

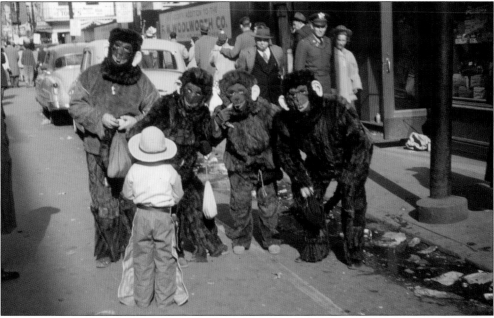

A little cowboy bravely confronts a quartet of much larger primates in 1953. The Woolworth's building under construction in the background is significant. This New Orleans Woolworth's, located at the corner of Canal and North Rampart Streets, was the scene of a confrontation at the segregated lunch counter in September 1960: a historic and peaceful sit-in by five black and two white college students from the Congress on Racial Equality (CORE). The sit-in followed a similar protest in February of that year at a Woolworth's in Greensboro, North Carolina. That Woolworth's became a museum, but this one was demolished in 2015 to make way for blocks of condominiums and apartments. CORE also opposed the Zulu krewes.

Two

SECOND LINE

ORIGIN OF NAMES OF STATES, SECRETS OF THE CRACKER JACK, AND MORE THAT AIN'T THERE NO MORE

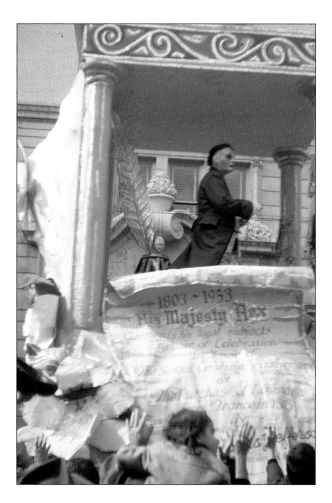

The Rex parade of 1953 used a proud "proclamation" by King Rex to call attention to the year being the sesquicentennial of the 1803 Louisiana Purchase—the land sale by a desperate Napoleon Bonaparte of France to the government of Thomas Jefferson. It was the mighty transaction that allowed Louisiana to join the young United States (12 other states would be carved from the territories acquired in the purchase), and it enriched Napoleon's war-depleted treasury by $15 million. The Krewe of Alla also centered their 1953 procession on the milestone anniversary.

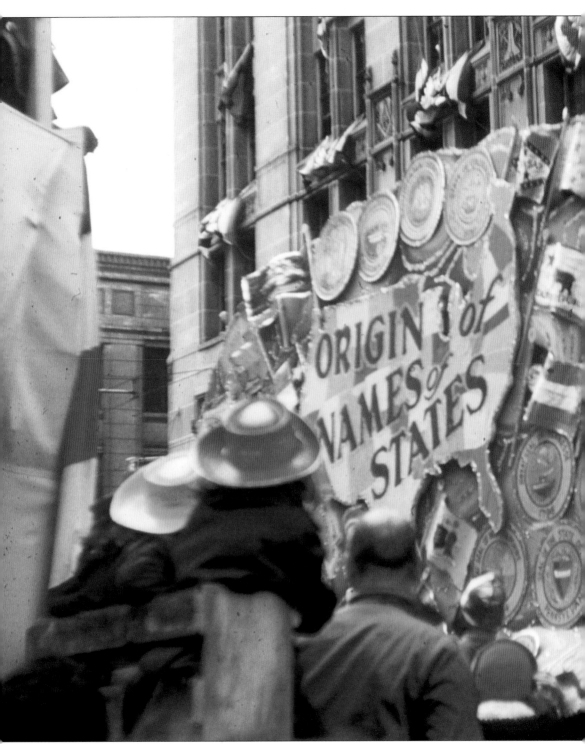

While it may look like a large loaf of bread to the untrained eye, this float actually heralded the theme of the 1953 Rex parade, "Origin of Names of States." The float bears re-creations of 50 state seals. It might be noted, however, that there were not 50 floats in this particular procession

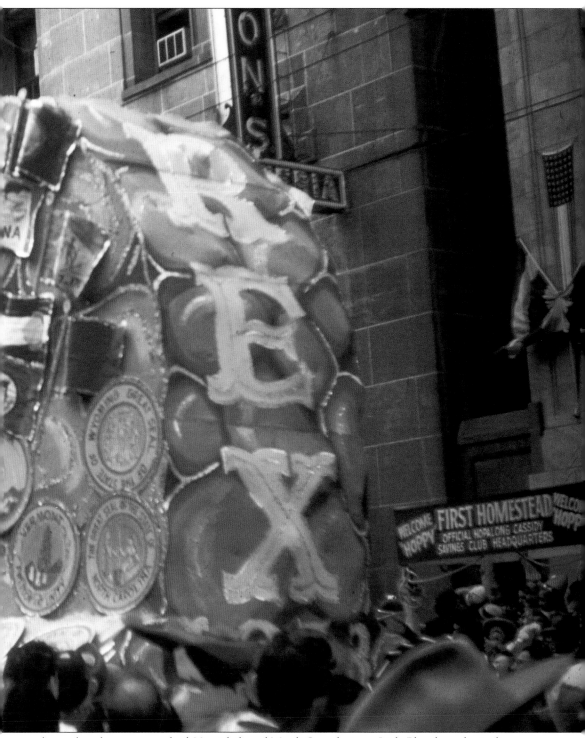

but rather the more standard 20, with famed Mardi Gras designer Léda Plauche only singling out certain states for individual visualizations.

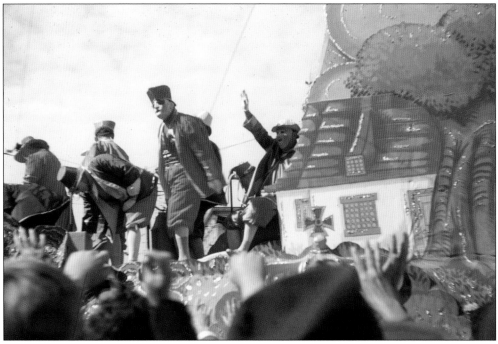

Pictured is a detail of the float representing the state of New York; it is one of the Léda Plauche creations for the 1953 Rex procession, "Origin of Names of States."

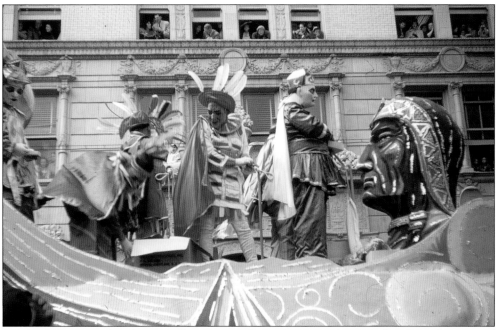

While old-line parading krewes adhered to tradition (even regulations) that floats be original creations every year, it was a common practice for figures and decorations of floats—between being sequestered in dens—to be pulled from storage, repainted, and reused in new contexts.

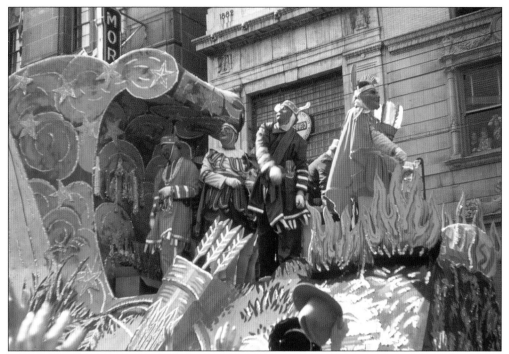

Members of the Rex Krewe in the 1953 procession, "Origin of Names of States," send out the throws from the Léda Plauche–concocted float commemorating the state of Illinois.

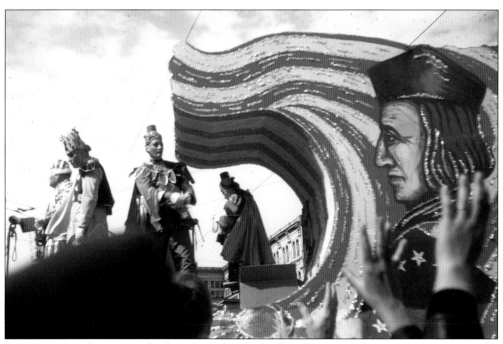

Spectators eagerly grasping for throws nearly obscured Ruth's view of the patriotic pageant in the 1953 Rex parade. This float, created by the eminent float and costume designer Léda Plauche, represented Washington in the "Origin of Names of States" procession.

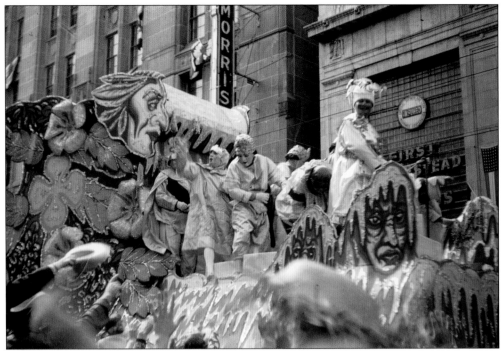

For the 1953 Rex parade "Origin of Names of States," float planner Léda Plauche imagined California as a blend of lush blooms and wintery frost-giants. Note that crowds are reaching for throws and the piles of heavy-looking glass-bead necklaces at the forefront.

The finale of the 20 floats that designer Léda Plauche mapped out for the 1953 Rex parade, with the theme, "Origin of Names of States," was for the state of Louisiana. Accordingly, it made a tableau vivant out of the court of King Louis IV of France. Costumed characters represented the explorers, missionaries, soldiers, and merchants who explored the upper and lower Mississippi River in King Louis's name.

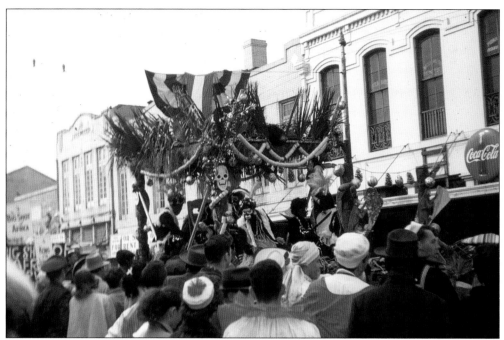

Shown here is the Witch Doctor float in the Zulu parade of 1953 (with signs behind announcing that the Big Shot of Africa and Kong of the Jungle were coming up next). Despite the elaborate costumes and decor photographed by Ruth here at Rampart and Poydras Streets, funds were running low for the embattled Zulu krewe in that period, as the rising tides of the civil rights movement stood against their imagery. Noel White, King Zulu for that year, was quoted in *Jet* magazine complaining that his procession was hindered by a coconut shortage and a flat tire.

Ruth caught a whimsical rear view of one celebrant riding piggyback on another in Bourbon Street in 1953. Lining the thoroughfare are some of the most renown burlesque houses of the French Quarter, including the ShoBar, the Zebra Lounge, and the Casino Royale. Over the next several decades and into the early 21st century, the ShoBar (or at least enterprisers trading on variations of the name: ShoBar, Sho Bar, or Sho-Bar) hopped to different addresses up and down the street. It was the most visible survivor—if only by reputation—of the Bourbon Street fleshpots of the 1950s. In 1955, the ShoBar was where the stripper Blaze Starr, then 23, commenced her famous love affair with the then-married Louisiana governor Earl Long.

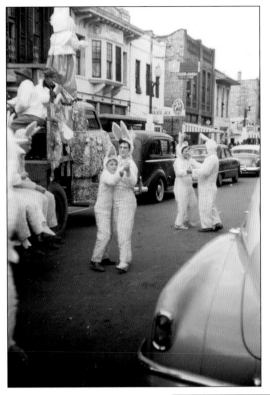

"Truck parade" krewes have been part of Mardi Gras since 1935. This one by the Elks featured a Dixieland jazz band, and Ruth got an informal picture of its bunny-suited paraders dancing on South Rampart Street. In the background, at 435 South Rampart, is Cracker Jack, a modest store recalled by folklorists as one of the French Quarter's most famous and authentic vendors of hoodoo and Voodoo and conjure-magic ingredients. Celebrated in song and visited by the likes of Zora Neale Hurston and numerous jazz musicians seeking its mojo, the Cracker Jack sold luck charms, potions, herbs, patent medicines, and gris-gris components. It was not tourist-oriented, as later Voodoo stores were; allegedly, outsiders were not even served. The Cracker Jack was unceremoniously demolished along with the rest of the block in 1974.

A crowd scene on South Rampart shows a lull in the parades. According to Ruth's captions, the pink basket belongs to a street performer taking in coins between dances. Many businesses owned by and servicing the African American, West Indian, and Creole community thrived on South Rampart. The red sign at upper right designated Perrault's Photo Studio, founded by Arthur Perrault. Arthur and his sister Florentine (a woman of color who was also a professional photographer) left behind their own collection of precious images, which were only recently rediscovered and reappraised as representing early 20th-century black life in New Orleans.

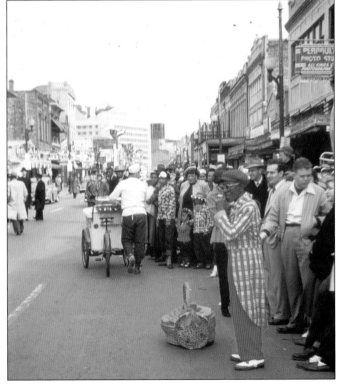

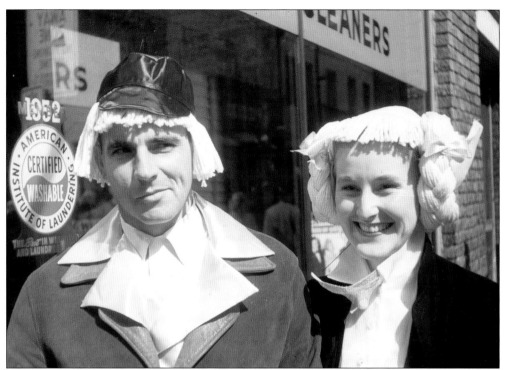

Ruth captured memorable facial expressions on this couple, bewigged and attired as a Dutch boy and a maiden, in the 1953 celebration. According to corporate history, the model for the classic Dutch Boy paint logo was actually a New York lad of Irish American descent named Michael Brady, who just happened to live close to the commercial artist Lawrence Carmichael Earle when Earle first created the logo in 1907.

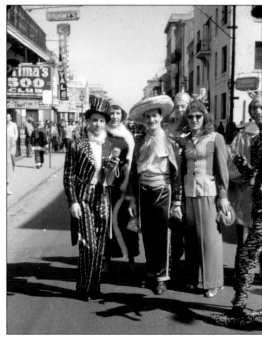

A fancy group posed for Ruth on Bourbon Street in 1953. In the background is Stormy Lawrence's Casino Royale as well as Prima's 500 Club. Leon Prima was the older brother of bandleader Louis Prima and would sometimes play trumpet in Louis's ensemble. After moving to New Orleans, Leon led his own band and managed assorted burlesque houses and jazz bars. The headliner at the 500 Club was Lilly Christine (born Martha Theresa Pompender), aka "the Cat Girl," a striking blonde exotic dancer of Amazonian proportions. It is said that even during hurricane warnings, patrons still lined this block for her "Voodoo love potion" routine. Leon Prima withdrew to the more staid world of real estate in 1955; the 500 Club continued into the 1960s and 1970s minus the Prima name.

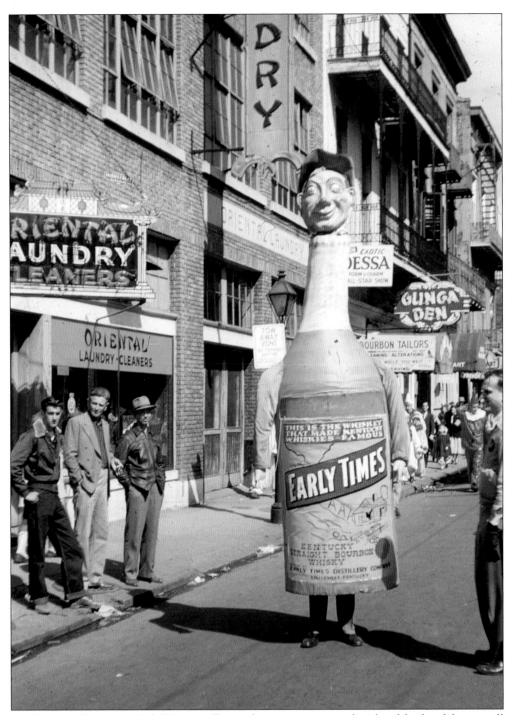

On Bourbon Street, an Early Times walking advertisement topped with a false head fits in well with the Mardi Gras marchers of 1953. Early Times, distilled by the Brown-Forman Corporation of Kentucky since 1923, remains a popular whiskey although it is a matter of legal technicality whether it qualifies as straight whiskey or (as it is marketed overseas) genuine bourbon.

A bizarre black-and-silver figure—perhaps an ambulatory traffic light (or not)—stood out, with a little cowboy companion, on Canal Street in 1953. Behind them is Leonard Krower's, a well-remembered merchant of jewelry and watches. One of the many emporia that, in local vernacular, "ain't dere no more," Leonard Krower's block at Canal Street and Exchange Place later became home to a Burger King.

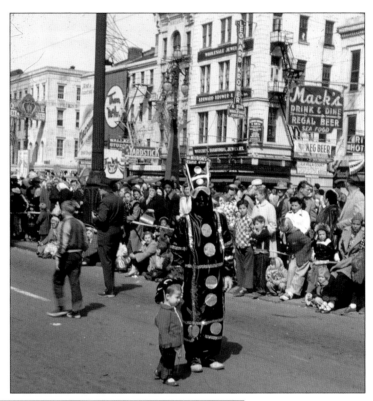

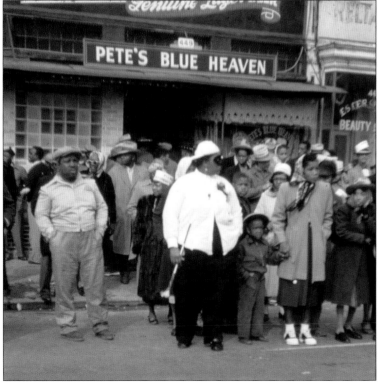

Crowds await the next sight on South Rampart Street. Early jazz greats frequented this block, and in addition to being a favorite R&B music club, Pete's Blue Heaven (which, from the 1920s to the 1940s, doubled as a pawn shop) was a favorite for the Zulu Krewe. Zulus even held funerals for their members there. Before the 1950s ended, much of this historic complex was redeveloped as civic buildings and parking lots.

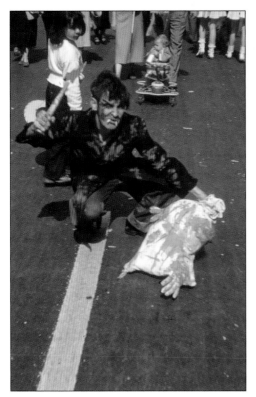

Years separate two macabre ax-murder tableaux: one from 1950 (at left), with a fanged maniac over a bloody torso, and one from 1953 (below), with a lunatic gang gathered around a dismembered dummy. Both scenes recall the 1918–1919 reign of terror by the "Axman," a never-caught serial murderer who struck from the French Quarter to Gretna, bludgeoning or killing numerous victims and inciting public hysteria. To this day, it is uncertain whether there really was a single elusive Axman or if the unsolved crimes were unrelated attacks stitched together by newspaper hype and panicked imagination.

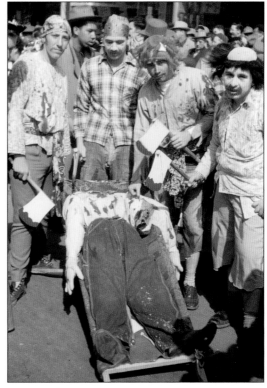

Pictured are two young superheroes on Bourbon Street in 1953, right at the tail end of what is officially regarded by comics historians as the Golden Age. In a 1947 Marvel Comics issue, none other than Captain America (and his sidekick Bucky) helped foil a jewelry theft at a New Orleans Mardi Gras parade. But attitudes toward comics changed, and the year after Ruth shot this picture, 1954, is notorious among fans of the funny pages for the US Senate Subcommittee hearings that probed alleged influences of action/adventure and horror comic books upon juvenile delinquency. The chilling effect led to publishers creating the long-running Comics Code Authority, which ended the Golden Age and lasted until it was finally abandoned in 2011.

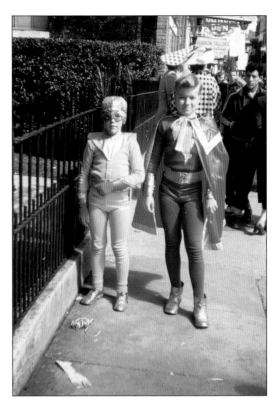

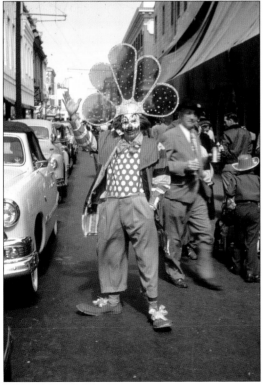

A polychrome clown in the 1954 carnival bears a resemblance to the NBC peacock logo, which was unveiled nationwide just two years later to announce the advent of color television.

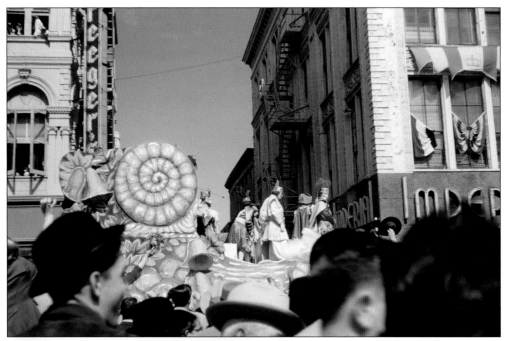

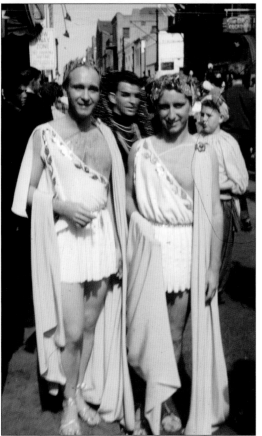

"Nature Creates, Man Invents" was the theme of the Rex parade of 1954. This float with a spiral motif is passing two Canal Street shopping destinations, Kreegers and Imperial Shoes. Kreegers, on the left, specialized in furs and operated from 1865 to 1986. It would allow customers to store their garments in the chains' own moth- and pest-proof vaults. When the final survivor of the Kreegers empire closed, some 4,000 furs were still being warehoused this way.

Names of the parading krewes, modern and old-line (as well as non-parading), often derived from classical Greek, Roman, and even Egyptian sources: Proteus, a shape-shifting sea god; Thoth, an Egyptian god of wisdom; Hermes, the messenger of Olympus, and so on. Then, there are the Mardi Gras Ball krewes, non-parading but still synonymous with the event: Knight of Momus, referencing a god of irreverence; Nereus, another sea god; and High Priests of Mithras, after the principal ancient Persian deity. This toga-clad duo in 1954 struck an apt note of antiquity on Bourbon Street.

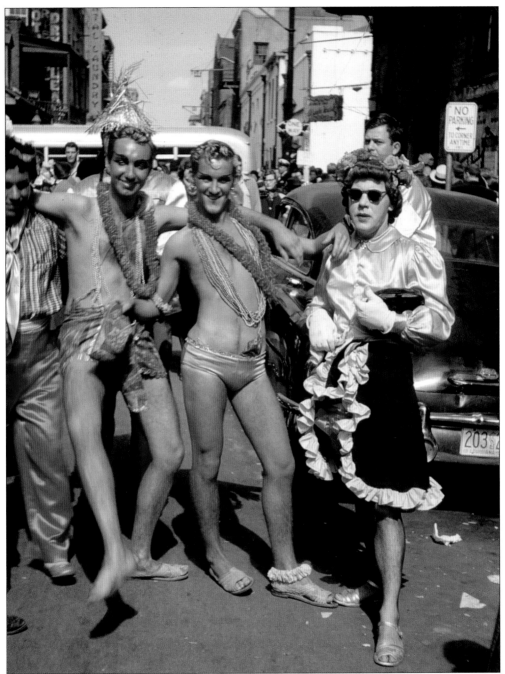

What would later be called "gender fluid," among other terms, was common practice at Mardi Gras. Heterosexual males could dress as women for laughs, while those more seriously interested in cross-dressing and homosexuality could indulge their most flamboyant sides in a climate of relative tolerance—though reporters still noted occasional attacks and assaults. The first outright gay carnival krewe, Yuga (which held balls but did not parade), formed in 1958 but disbanded four years later after pressure stemming from police raids. These campy gentlemen were photographed by Ruth in 1954; she labeled the slide "4 of 'them.'"

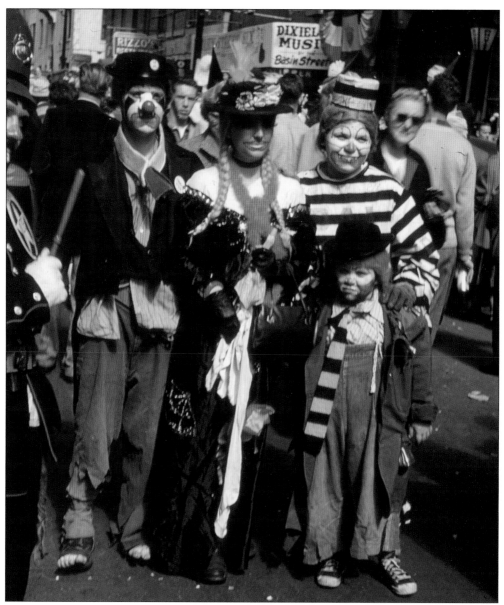

A family of clowns exhibits a prisoner-clown and hobo-clown theme (completed by a policeman clown at far left). In the background, a colorful marquee advertises the Basin Street Six, a highly esteemed sextet, formed in 1950, who performed and recorded Dixieland jazz. Members continued to play together into the 1990s. The clarinet virtuoso of the Basin Street Six was a French-Creole descendent named Pierre Dewey LaFontaine Jr.—better known by his performing moniker, Pete Fountain. Bourbon Street and adjacent avenues cultivated many fine native musicians because the music clubs seldom allocated money to bring in costly out-of-town performers. Thus, the area supported a number of full-time artists playing Dixieland jazz/ragtime; big band; boogie-woogie; country; blues (including a particular style called "barrelhouse"); and the brassy, blaring accompaniment to stripper acts. Of the musicians who worked these streets in this era, Pete Fountain, trumpeter Al Hirt, and dancer-vocalist Chris Owens would attain particular prominence, becoming club owners and business/community leaders in their own rights.

Three

FINALE

ROLLING INTO THE SPUTNIK AGE, AND THE RETURN OF THE BOEF GRAS

A glittery visage straight out of *A Midsummer Night's Dream* was captured by Ruth on Bourbon Street in 1954. Behind this image of the Fairy King is the somewhat less-than-Shakespearean Sugar Bowl, one of the decade's French Quarter burlesque clubs, which shared its name with the popular college-football game played annually in New Orleans since 1935. In regard to the bawdy entertainment along Bourbon Street, an irked writer for a local magazine opined in 1948, "Every day and night there's a Mardi Gras going on somewhere along Bourbon Street." He did not intend this to be a compliment.

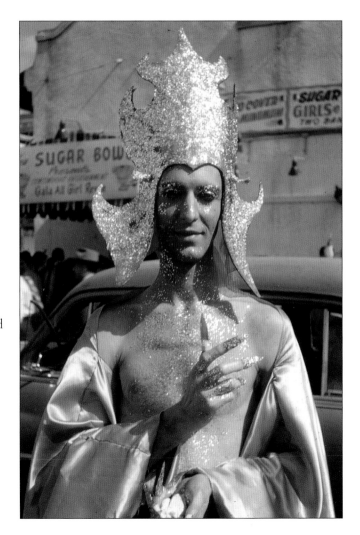

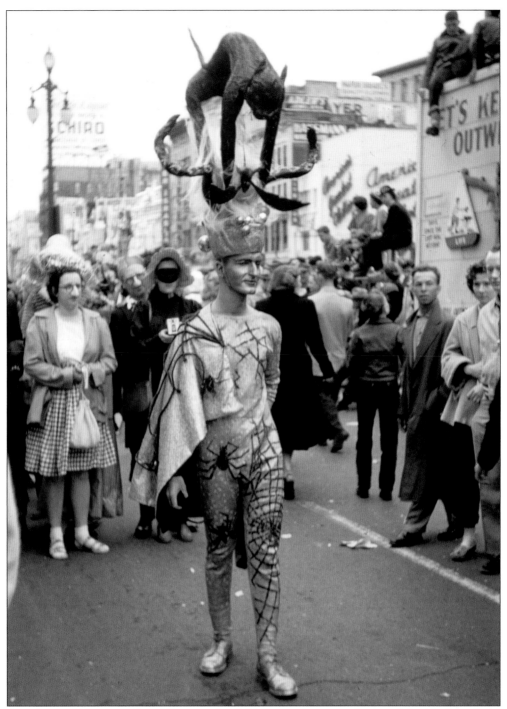

A striking gold figure on Canal Street in the 1954 Carnival is covered in occult/bad-luck symbols, including spiders, snakes, and a black cat. Adler's, a jewelry chain whose signage is shown among the merchants in the background, was far from unlucky. Founded in 1898, they continue to do business in a Canal Street address to this day, a rare survivor among the "ain't there no more" brand names that defined this thoroughfare in the 1950s.

"Every man a king" was the well-remembered line from a 1934 radio address by Louisiana's ill-fated governor Huey P. Long. Almost 20 years later, however, something like that promise came true, in a fashion, during the Mardi Gras of 1953, with these promotional giveaway paper crowns that advertised the Brown-Forman product, King Whiskey, "Kentucky Straight Bourbon Whiskey."

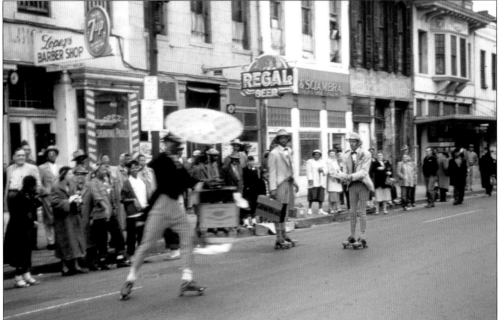

A roller-skating trio entertains the masses between floats during the 1954 Mardi Gras. Behind them is a sign for Regal Beer, one of the signature brews of the French Quarter. Regal ("lager" spelled backward), the self-crowned "prince of New Orleans Beers," was produced by the American Brewing Co. on Bienville Street. The brewery opened in 1890 and, after an interruption by Prohibition, slaked the thirst of generations of Louisiana beer-drinkers. The Regal jingle, "Red beans and rice and Regal on ice," was known to virtually everyone. The American Brewing Co. finally closed in 1962 (the site is now occupied by the Royal Sonesta Hotel), though nostalgic facsimiles of the beer and its commercial art continue to be marketed today.

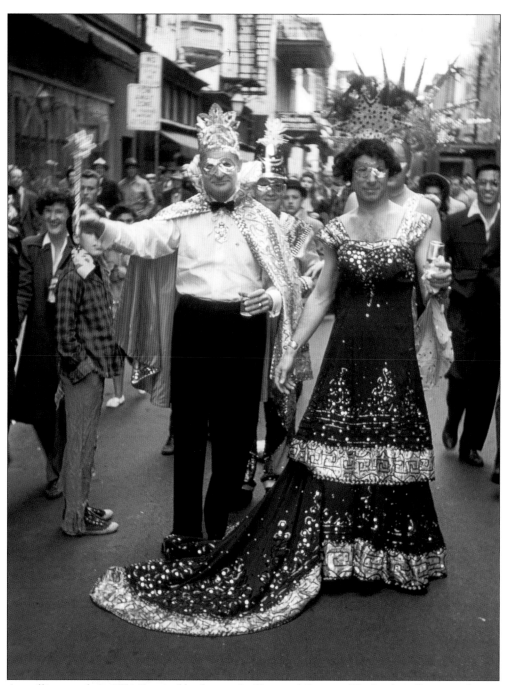

A strolling couple in 1954 Carnival burlesque the King and Queen of England—affectionately, one hopes. In that era, not only were memories of the royal wedding of Elizabeth II and Prince Philip still fresh, but Mardi Gras had enjoyed a celebrated visit in 1950 from the Duke and Duchess of Windsor. The royals attended the grand balls given by both the Comus and Rex Krewes. It was considered a great honor indeed when the Windsors bowed and curtsied to the King and Queen of Comus, as well as the Rex King. A well-recalled Krewe of Osiris grand ball in 1947 was based on a recreation of the coronation of King George V in 1911.

Hitchhiking became popular with the rise of the automobile, but by the 1950s, it was starting to acquire a reputation for danger and risk-taking. In fact, a killer named Billy Cook earned his notoriety in a Missouri-to-Illinois hitchhiking crime spree, during which he murdered six people (finally obtaining a vehicle by wiping out the owner and his family). A movie inspired by the case, *The Hitch-Hiker*, premiered in 1953. Still, in the Carnival the next year, this grotesque female figure strikes the classic hitchhiker "come-on" pose, exposing some suspiciously masculine leg.

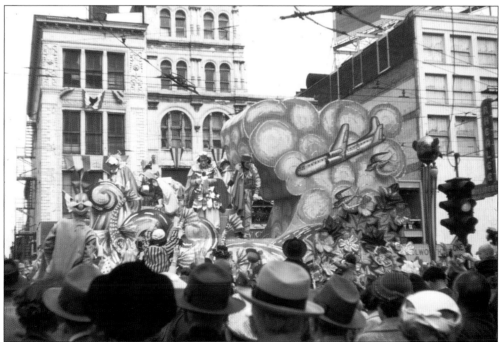

A float from the "Nature Creates; Man Invents" theme of the Rex parade of 1954 showed Canal Street spectators the evolution of man-powered flight from birds. Do not assume the stone-faced figures on the float are not having fun behind their stoic masks; it is longstanding (practically compulsory) Mardi Gras tradition that all who man the parade floats be masked.

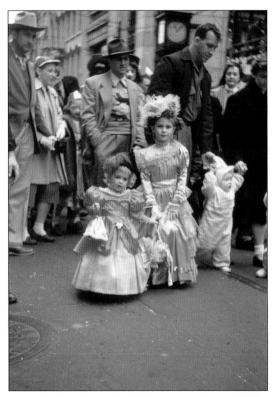

These two images represent yesterday and tomorrow 35 millimeters apart. In 1954, Ruth photographed the children of New Orleans at Mardi Gras on practically adjacent frames, telescoping in and out of two vastly different and romanticized time periods. At left are children in lush lavender mini-gowns recalling the genteel antebellum past, and below are a pair of shiny metallic robots, visions of the nascent "space age" for a future that has not yet dawned (at least not quite like this).

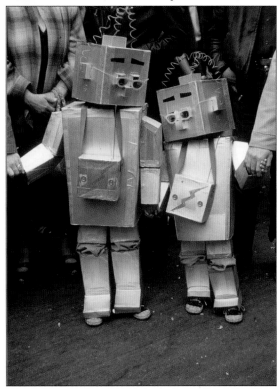

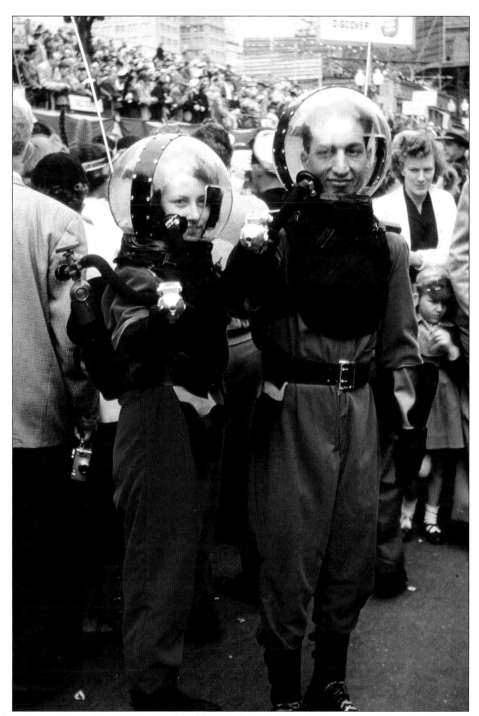

The 1953 Universal Pictures comedy *Abbott and Costello Go to Mars* had a subplot in which the comedy duo landed in the midst of a New Orleans Mardi Gras by mistake. The bizarre costumes make them believe they have indeed discovered alien life. The next year, 1954, Ruth Ketcham photographed these vivid astronauts in violet-blue space suits toting zap guns every bit as fancy as the ones then being portrayed on the silver screen.

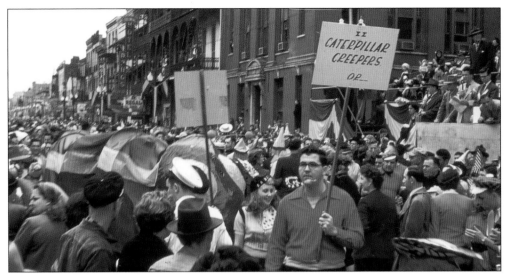

Long before filmmakers had conceived of human centipedes, "Caterpillar Creepers" was the name of this walking krewe completely concealed by their mass costume in the 1954 Carnival. When turned around, the explanatory sign punned on a popular song title, "Larva Come Back to Me."

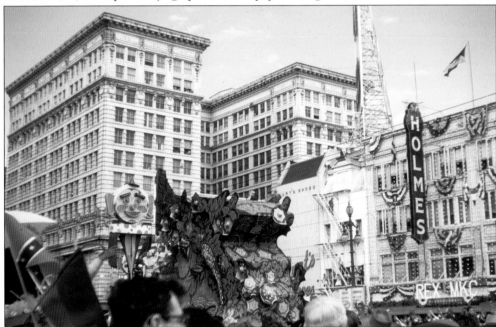

A float in the Rex parade of 1954 proceeds past probably the two greatest landmarks of the Canal Street shopping zone. One is the Maison Blanche, a vast 1909 building that housed retail empires and medical offices (the latter on the upper floors). The adjacent D.H. Holmes Department Store bears the name of the 19th-century magnate whose flagship emporium was, for a long time, the largest and finest department store in the south. Throughout the 1950s, the exterior of the Holmes building (which dated to 1913) was modernized and updated, but Holmes ceased business as a retailer in 1989. Both buildings entered the 21st century renovated as hotels, with the Maison Blanche housing the New Orleans Ritz-Carlton and Holmes becoming the Hyatt French Quarter Hotel.

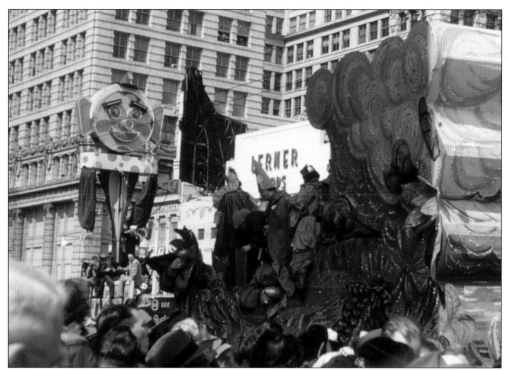

Even the street lights of Canal Street wore costumes in the 1950s. Here, a 1954 Rex parade float drifts past the Maison Blanche building; note the cluster of servicemen photographing the procession at the lamp's base from the vantage opposite Ruth's lens.

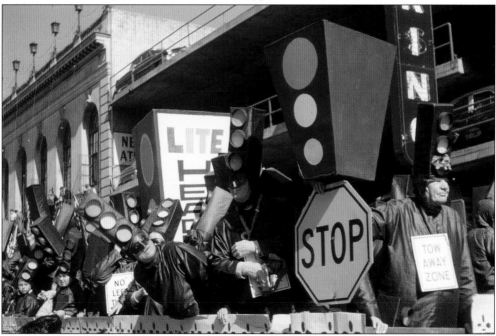

A simple but brilliant costume/float idea, "Lite Heads," is shown being brought down Rampart Street by a truck krewe in the 1954 celebrations.

At Mardi Gras, there is very little that is not larger than life. Ruth found wildly enhanced "dragonfly" eyelashes a captivating subject, as shown here on a 1954 clown (left) and a 1958 onlooker (below) sporting faux follicles that could probably be seen all the way across Lake Pontchartrain.

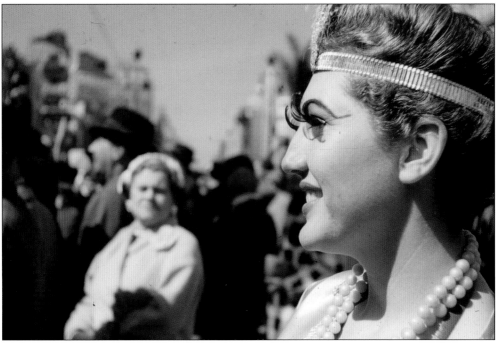

Civil rights activist and politician Constance Baker Motley, who assisted Thurgood Marshall in the landmark *Brown v. Board of Education* case, wrote, "New Orleans may well have been the most liberal Deep South city in 1954 because of its large Creole population, the influence of the French, and its cosmopolitan atmosphere." Her words go nicely with this jaunty gathering of young people encountered by Ruth on Rampart Street during the 1954 Carnival in an image that seems to brim with promise and easygoing optimism.

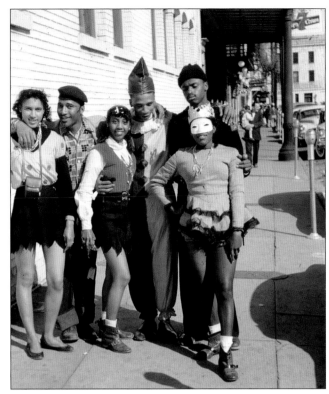

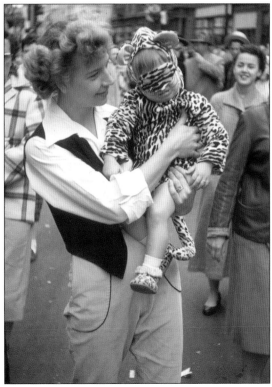

Long before the Disney book series and television movies about a band called the Cheetah Girls, Ruth found this actual "cheetah girl" in the 1954 Mardi Gras. Unfortunately, she did not seem to enjoy being in front of the lens.

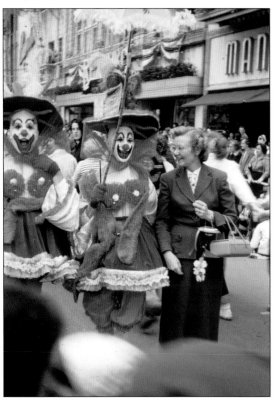

A pair of parasol-bearing clowns (with their tulle flowers in some rather suggestive places) did not seem to faze a very proper lady at the 1956 Mardi Gras.

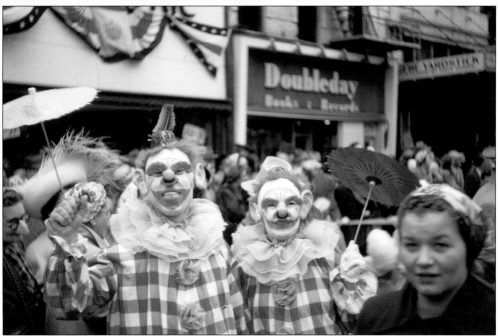

Coulrophobia is a word that the psychiatric community invented around the 1980s to describe a dread fear of clowns. For suffers of this affliction, Mardi Gras could be a dangerous place, as proven by this duo from 1952.

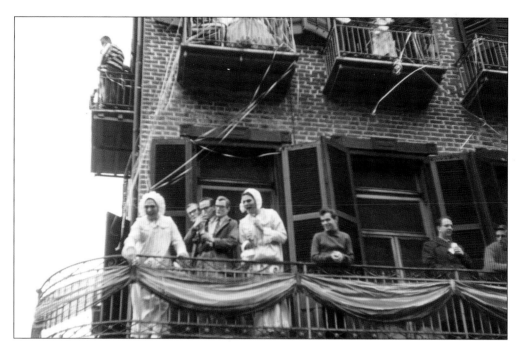

Not every eye-catching reveler at Mardi Gras was at eye level. Visitors who failed to look up in 1958 would have missed this balcony containing two adult infants and a bizarre three-headed man.

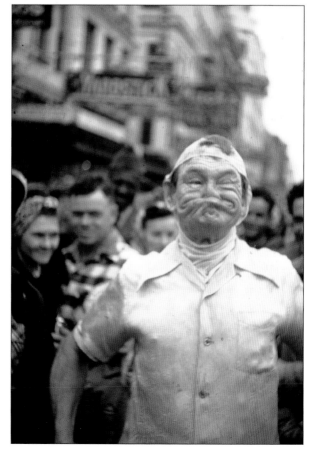

No mask was required (even though he obviously wore one) in the case of this 1952 reveler, who demonstrates the venerable art of gurning—the ability to make one's lower lip cover as much of the nose and upper face as possible. An old English tradition, gurning actually has a world championship, which has been held in Egremont, Cumbria, in the United Kingdom for more than a century.

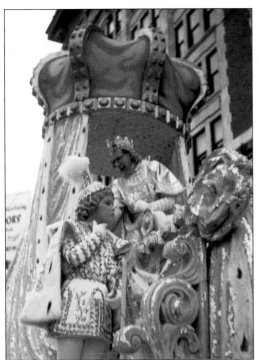

The Rex King of the 1956 Mardi Gras was Edgar A.G. Bright, a well-known local financier, here attended by the customary page. Members of the Bright family had reigned as Carnival kings and queens since 1879 and would continue to do so into the 21st century. It is traditional for the Rex King to sport a suitably regal beard, and those in the 1950s came equipped with their own homegrown crops for the occasion. Later Rex Kings would often utilize synthetic beards instead.

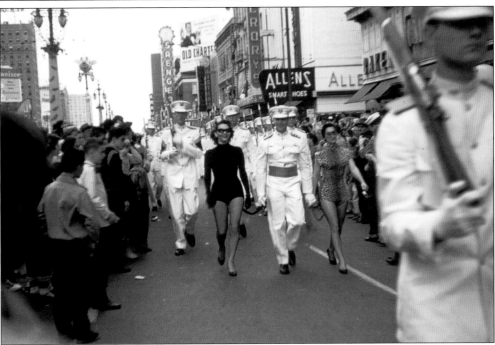

Two exquisitely feline and feminine young ladies march alongside students from Texas A&M University (TAMU) on Canal Street during the Rex parade of 1956. With a satellite campus located in Galveston—a city that has presented its very own Mardi Gras since 1911—the great university is particularly invested in Carnival. TAMU also serves as a senior military college, as evidenced by this smart assembly of cadets.

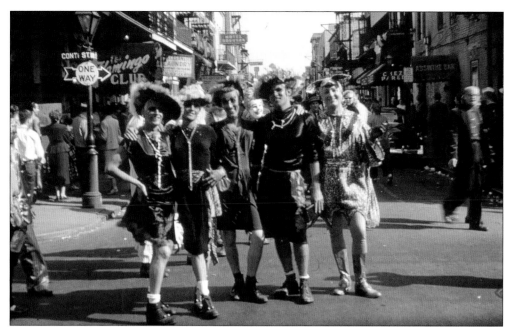

A quintet of cross-dressers poses for Ruth at the intersection of Bourbon and Conti Streets in the 1956 Mardi Gras. On either side are lounges and bars that gave this particular thoroughfare its notoriety, including the Flamingo Club, to the left, one of the places especially targeted in the early 1960s by controversial district attorney Jim Garrison in his fight against prostitution, obscenity, and the illegal practice of "B-drinking" (in which dancing girls took a cut of the profits from the drinks they enticed men to purchase). Two dozen clubs eventually succumbed to Garrison's crusade, the Flamingo among them.

Sometimes, the least ostentatious Mardi Gras costumes, properly worn, can make the greatest impression. These two men on a Bourbon Street corner displayed quite a bit of skin in the 1956 Carnival. The reaction of the woman in the background at right is priceless.

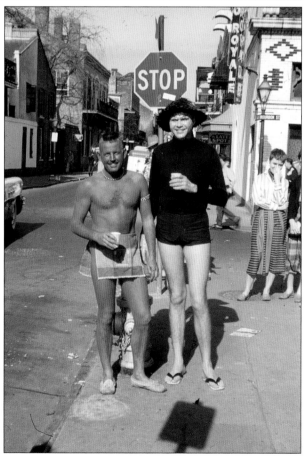

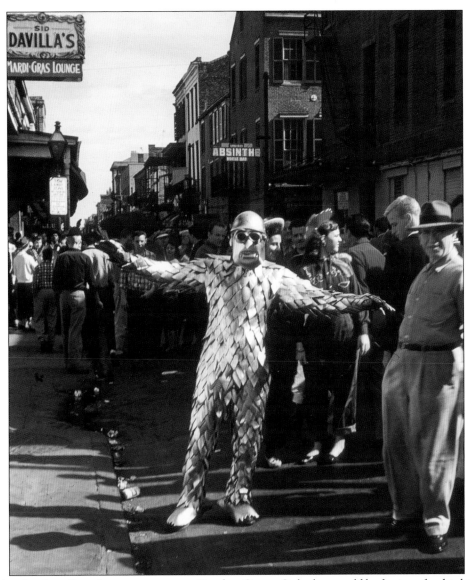

A head-to-foot silver phantasm cavorts on Bourbon Street. Onlookers could be forgiven for thinking they had merely hallucinated this figure after too much indulgence at the Old Absinthe House, a venerable establishment long known for serving the infamous green-colored, wormwood-based liquor, dubbed "the green fairy" in its native France. Accused of triggering strange visions and associated with rebels, artists, and rascals, absinthe was banned in the United States in 1912. A milder formula called Herbsaint (with a far less bitter flavor of wormwood, dubbed "petite absinthe") was bottled by New Orleans entrepreneurs in the post-Prohibition era. Modern opinion is that the fatal reputation of absinthe was exaggerated, perhaps because of contaminants. The Old Absinthe House was said to be a site of parlays between the pirate-hero Jean Lafitte, Andrew Jackson, and local authorities defending the town during the War of 1812. In the 1950s, a favorite joke was to lead Absinthe House visitors to a life-sized upstairs diorama. At the appropriate moment, one of the "statues" would come to life, terrifying the rubes. The building was later extensively renovated, with a striking white facade, and the famous blocky metal sign shown here was retired after storm damage from Hurricane Katrina.

Ruth found four subjects on Royal Street outside of the Adam Comeaux lounge and bar in 1956. This corner had been one of the on-location shooting sites for the Hollywood feature *New Orleans Uncensored*, a crime drama directed by William Castle for Columbia Pictures and released just after Mardi Gras in 1955. "Filmed at White Heat at the Bottom of Desire Street" was the poster's tagline, which could also be an arch caption for this Valentine's Day–like family grouping.

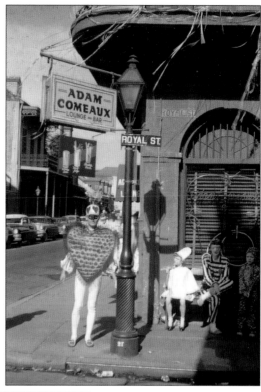

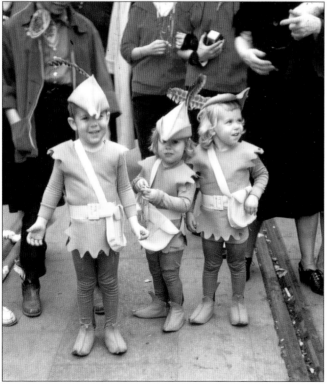

A trio of Robin Hoods walked among the children in the 1956 Carnival. The previous year, 1955, featured the American premiere (on CBS television) of *The Adventures of Robin Hood*, starring Richard Greene, a fresh launch of the durable Sherwood Forest hero (from Lew Grade, the same British producer who would later help create *The Muppet Show*). Even if the show did not inspire the same fervent devotion as Disney's *Davy Crockett* did in the 1950s, it is still fondly remembered.

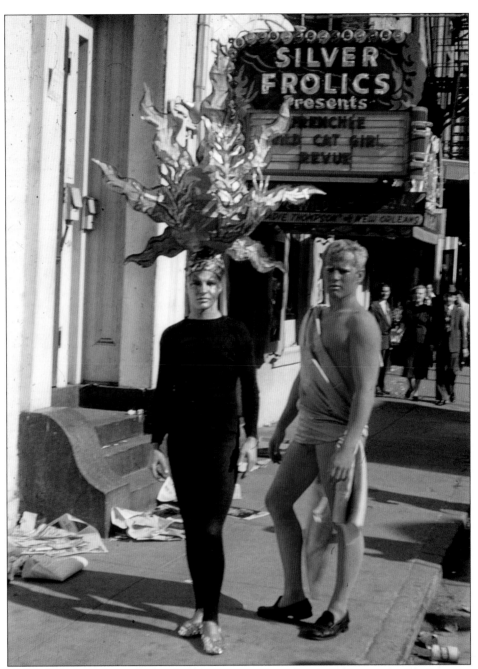

A striking duo, including a man with a most extraordinary hat indeed, poses on Bourbon Street, doing a heroic job of not quite outshining the marquee for the Silver Frolics nightclub. Located at 427 Bourbon, this was one of the more notorious strip clubs of the French Quarter, and in the early 1960s, it became a target for raids overseen by New Orleans Parish district attorney Jim Garrison in his drive to cleanse the neighborhood of its notorious (and, one must say, rather popular) vice. In 1963, under Garrison's orders, the Silver Frolics was one of five clubs repeatedly harassed and effectively driven out of business. According to contemporary news accounts, public sympathy leaned more toward the strippers.

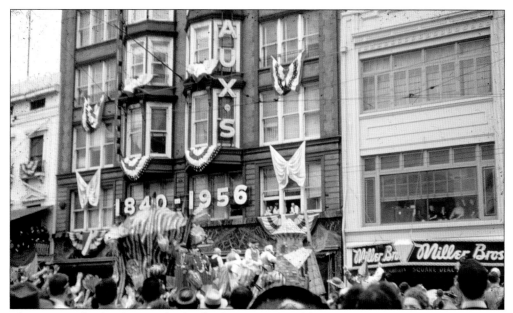

The Rex parade of 1956 passes by the flagship store of Godchaux's— arguably, along with the D.H. Holmes company, the crown jewel of the old New Orleans department stores. The Leon Godchaux Clothing Co. was founded in 1840 by the self-proclaimed "sugar king of the South." Long after Leon Godchaux's demise, this Canal Street location had the finest and most exclusive fashions and housewares the Crescent City had to offer. The Godchaux's store chain folded in 1986.

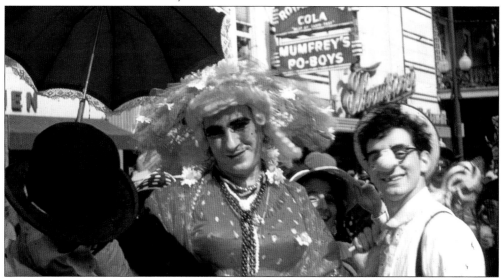

Three gender-fluid grotesques from the 1956 Carnival are pictured near one of the numerous po-boy sandwich purveyors in the French Quarter. Origins of the po-boy sandwich are much disputed but are generally said to reside with Benny and Clovis Martin, vendors near the French Market who took split open half a loaf of French bread and filled it with ham, oysters, or whatever customers desired. The Martin brothers took credit for codifying the "po-boy" name in response to a notorious streetcar-drivers' strike in 1929, supposedly donating free sandwiches to the "poor boys." But the *Times-Picayune* newspaper found published references to similar repasts with "po-boy," or variations on the name, well preceding 1929, with some even dating to the 1800s.

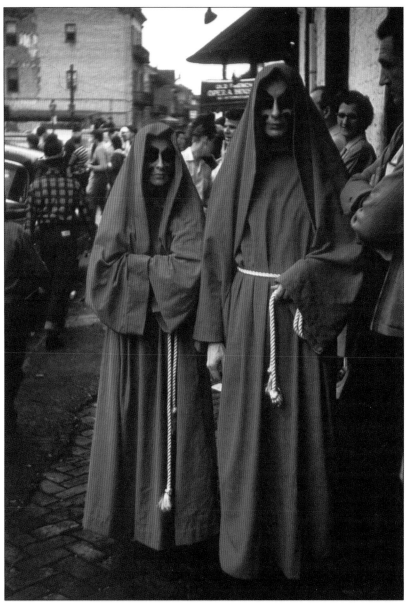

A rain shower during the 1956 Carnival lent Kodachrome film appropriately somber hues for this duo of red-clad monkish figures. Their phantom-like demeanor matches the sign in the background for a nightspot named Old French Opera House in tribute to the French Quarter landmark that once stood near this site. Constructed in 1865, the French Opera House on the corner of Bourbon and Toulouse Streets was a jewel of the city in the latter half of the 19th century, and in addition to operas, it hosted numerous balls for the old-line Mardi Gras krewes. On December 4, 1919, after a cast had left following a run-through of *Carmen*, smoke began pouring out of the roof. With a fire feeding on magnificent costumes and props, the historic structure was entirely consumed (today, one can still see a widening of the street, a leftover from the days when horse-drawn carriages dropped off patrons). There was a volunteer group, "les Pompiers de L'Opera," devoted to fire prevention and extinguishing lit cigarettes during performances, but the Pompiers were never on duty for rehearsals. No wonder these apparitions seem so rueful.

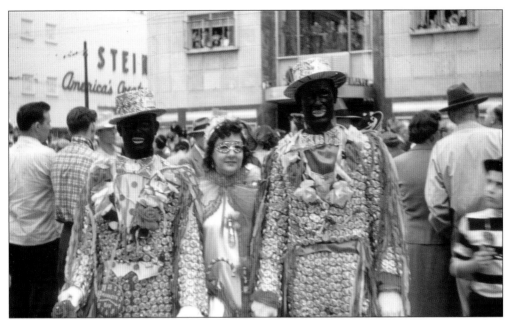

The blackface makeup on these costumed strollers photographed in 1956 is no longer palatable, but the costumes are; they are studded with hundreds of Coca-Cola bottle caps. Note the red badge for Markey's Bar worn by the gentleman at left. The saloon on Louisa Street in the Bywater neighborhood opened under Joe Markey in 1947 and became a particular favorite for the Irish of New Orleans, continuing in business into the 21st century under the same family ownership.

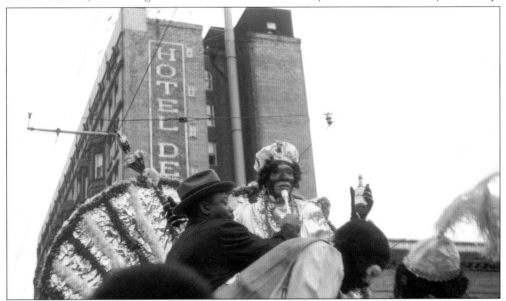

Albert Hamilton, the Zulu King of 1956, addresses his royal subjects in the shadow of the old De Soto Hotel on Poydras Street. Originally the New Dechenaud Hotel when it opened in 1907, the De Soto's 10 stories held a penthouse that housed local radio station WDSU until 1948. At basement level, an underground passage allowed Prohibition-era imbibers (many said to be local politicians) to escape to adjacent buildings in the event of a police raid. In 1970, the De Soto became the Le Pavilion Hotel after undergoing considerable makeovers inside and out.

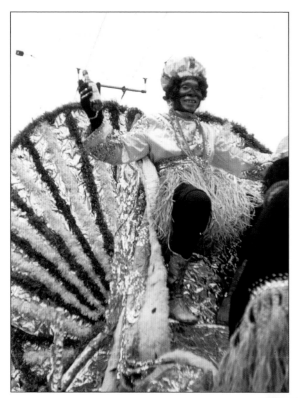

Albert Hamilton is resplendent as he luxuriates on his throne as the King of Zulu of 1956. Following after him, Gussie Baptiste, the Zulu Queen of 1956, looks appropriately regal on her float. The tradition of a "queen" to complement the monarch in the Zulu parade was a later addition to the Zulu Social Aid & Pleasure Club, being instituted in the 1930s.

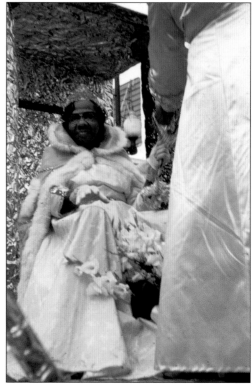

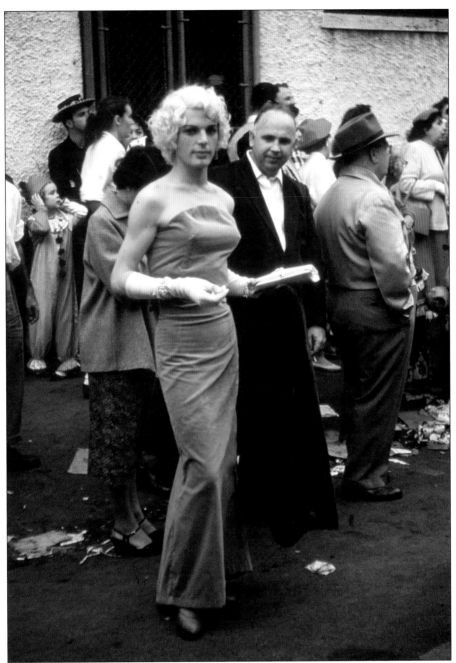

The 1950s (and color film) could not be complete without a cameo from Marilyn Monroe. The Hollywood screen goddess was likely an inspiration for this Carnival cross-dresser photographed by Ruth in 1956. The previous year, the actual Marilyn Monroe had been at top of box-office figures—and the headlines—for her performance in *The Seven Year Itch*, the end of her short-lived marriage to baseball great Joe DiMaggio, and a widely covered relocation to New York City to form her own production company and immerse herself in the *tres* serious atmosphere of the Actors Studio and the Manhattan intelligentsia. In June 1956, the celluloid siren stunned her fans with an odd-couple wedding to owlish playwright Arthur Miller.

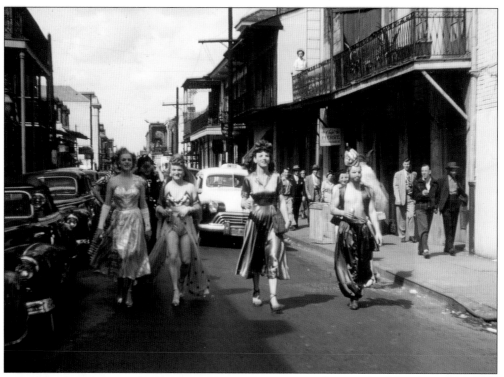

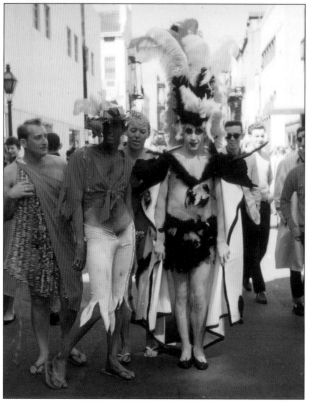

A strong "girls' night out" vibe emerges from these images of cross-dressers during Carnival in 1950 (above) and a scene from 1958 (below). Open homosexuality in New Orleans—a risky affair in the 1950s—was highly visible during Mardi Gras, when the tradition of masquerade permitted men to dress and comport themselves in whatever flamboyant costumes they chose to sport. Who could discern a genuine "queer" element from anyone else attired in female finery for a laugh, and in the spirit of celebration, why care? A tall tale told about Bourbon Street in particular claims that one nitery drew crowds with a cross-dressing cabaret. At one point, the dancers all walked out during a strike for higher wages. Management simply substituted genuine female dancers and successfully passed them off as men in drag.

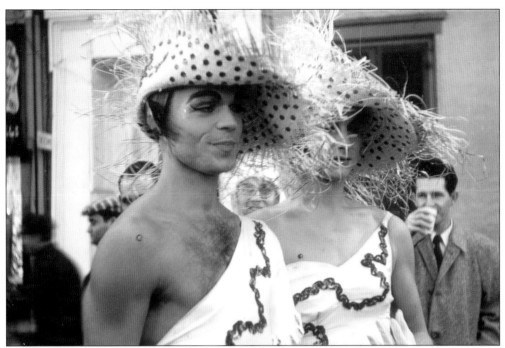

Outlandish headgear and hats
were frequently photographed
by Ruth Ketcham, and the latter
1950s offered a veritable millinery.
She captioned the gold-colored
orientalist fantasy at right as a
"Buddha," although that may
be open to interpretation.

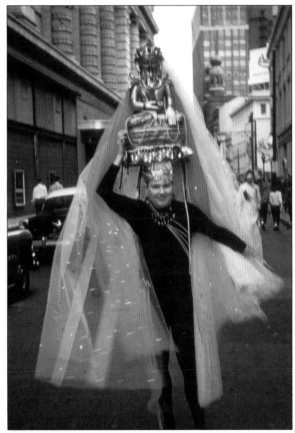

In 1956, Ruth photographed a gentleman
in ballerina drag on Bourbon Street
with poise that would have been quite
at home in the Ballets Russes.

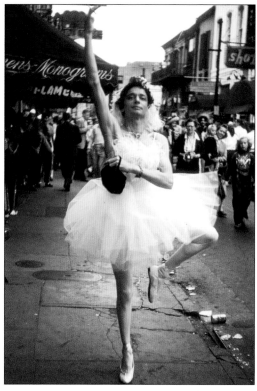

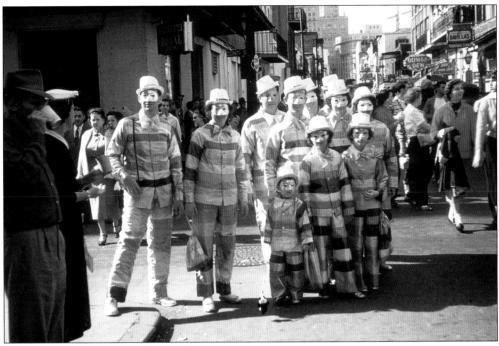

At the intersection of Bourbon and Conti Streets in 1956, Ruth found what was either a rather small walking krewe or a very large family well attired for the Kodachrome spectrum. Rarely was Bourbon Street associated with family outings. Once the most populous residential street in old New Orleans, the thoroughfare had enjoyed a post–World War II boom as a place for overindulgence and sin, and this image includes the signage of some of the notorious drinkeries and cabarets. It is said that one major draw for the riffraff was a novelty to which many 1950s households could relate—near the dawn of the decade and virtually all at once, the Bourbon Street saloons installed television sets as a new "behind the bar" attraction.

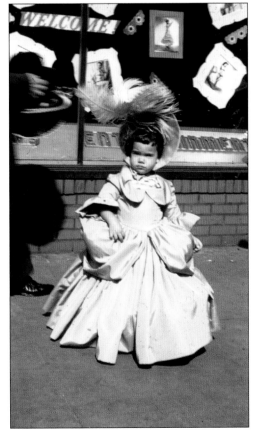

Intentionally or not, Ruth contrasted the innocence of a little girl in her finery in the 1956 Mardi Gras against the cheesecake photographs of headlining strippers in the French Quarter and Bourbon Street. According to muckraking reporters Jack Lait and Lee Mortimer, one New Orleans nitery of the era employed only "midgets" as waitstaff to ensure that the clientele's view of the women on stage was never blocked.

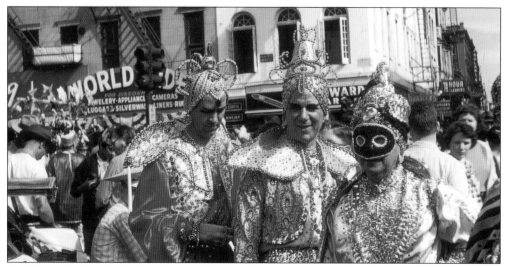

Ruth's caption for this 1956 gathering of bizarre Carnival revelers identifies them as "sultans." One of the colorful tall tales of Vieux Carre horror from colonial days involves the "Sultan," identified by storytellers as the fugitive prince in a Middle Eastern caliphate, marked for death by his reigning potentate brother. Either France or Spain grants the rebel Sultan sanctuary and sends him to safety as far away as possible, in colonial New Orleans. This is still not enough, and in the night, a strange ship anchors at the docks, and mysterious figures prowl the streets. In the morning, bystanders see blood pooling from under the door of the Sultan's residence-in-exile. Inside are the servants and concubines, all massacred. The strange ship and the Sultan are never seen again.

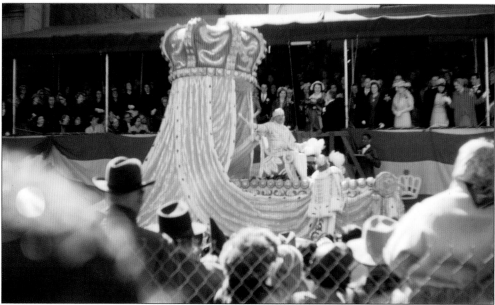

The Rex King of 1958, shown passing before the Boston Club, was Joseph Merrick Jones, a distinguished lawyer; assistant secretary for public affairs in President Truman's State Department; and a prolific Washington, DC, speechwriter. In 1947, he assumed the presidency of the Board of Tulane University. On March 11, 1963, Jonus and his wife died in a house fire in Metairie. He had just announced that Tulane would start the process of racial integration, and there are those who suggest it was a double-murder by arson, although that charge has never been proven.

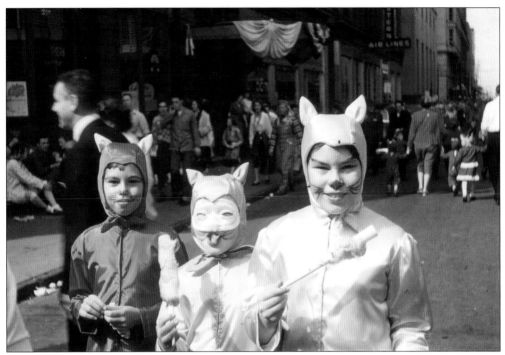

A trio of cotton candy–loving children in catlike costumes in 1956 recalls the closing lyrics of the Mardi Gras anthem "If I Ever Cease to Love." It goes, "May we all turn into cats and dogs/If I ever cease to love." The popular 1871 song by Britain's George Leybourne came to the United States with traveling entertainer Lydia Thompson and became attached to Mardi Gras in 1872. It never left, in contrast to some of the businesses in the background. The Southern Pacific Railway, with offices in St. Charles Street, would, by 1958, cut back service to trains running between Texas and New Orleans. In the early 1960s, it ceased to run entirely. Eastern Airlines, known by that name since 1930, was the primary airline of the East Coast in the 1950s and specialized in warm-weather destinations (with added services to Canada starting in 1956). Eastern did not survive the multiple airline mergers and closures of the 1980s, and it was gone with the wind by 1991.

The Krewe of Babylon parade of 1958 featured a float inspired by grand opera (Wagner, in this float's case). Here, it passes by two "ain't there no more" Canal Street retailers of women's apparel. Goldring's joined the many department stores now departed, and while Gus Mayer no longer operates on Canal Street, branches continue to do business in Birmingham and Nashville.

A float in the 1952 Rex parade is shown from the rear proceeding down Canal Street past the Werlein Music building. Philip P. Werlein published historical sheet music (including a disputed issue of the Confederate anthem "Dixie") throughout the 19th century and was an indispensable emporium for New Orleans musicians. According to legend, Louis Armstrong bought his first horn from Werlein's; the flagship store held recital stages and one floor devoted to pianos. The chain spread regionally, becoming one of the longest-lasting names in area retail. The last Werlein's closed in 2003. The 605 Canal Street address later housed a restaurant.

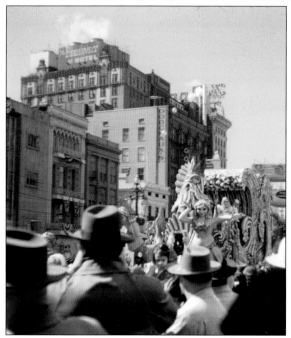

Though watery motifs tend to dominate Krewe of Proteus floats, the theme of the Rex parade in 1958 was Hans Christian Andersen and his fairy tales, thus this tribute to "The Little Mermaid." In the background is the now-departed Godchaux's department store on Canal Street, and behind it looms the Roosevelt Hotel, still in existence. The 1893 structure opened as the Hotel Grunewald—particularly timed for Mardi Gras crowds —and was renamed 30 years later in honor of Pres. Theodore Roosevelt. As the property changed hands from 1965 to 2009, the hotel was known as the Fairmont New Orleans, but after post-Katrina renovations, the grand old lady (now managed by the Waldorf-Astoria hospitality company) reverted to the Roosevelt name.

Two Robin Hoods frolic on the lamppost at the corner of Royale and Bourbon Streets in 1958. Behind them is the well-remembered Casino Royale strip club, and in the window at lower right is an advertising display showcasing the star exotic dancer Alouette LeBlanc (real name Ruth Corwin), renowned as burlesque's greatest-ever "tassel spinner." Her specialty was four tassels, with two attached to her front and two to the rear. Such were her gyrations that she could send them twirling in opposite directions. She was one of the longest-running attractions on Bourbon Street, and a typically saucy tale claims that one night while dancing her routine, a poodle, transfixed by the tassels, leaped on her and clamped its teeth on her bosom.

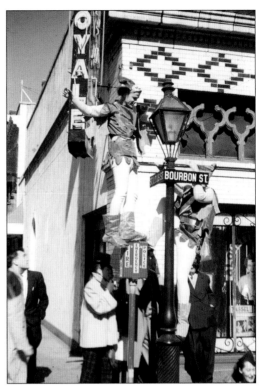

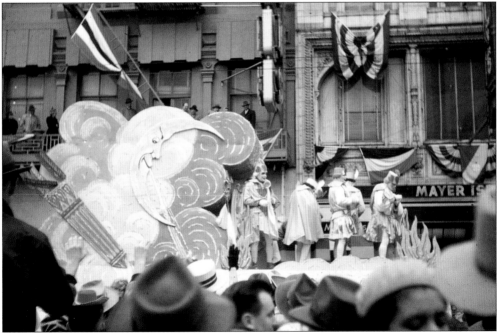

A fanciful float in the 1952 Rex parade passes the facade of the Mayer Israel Department Store, one of many such emporia on Canal Street. Opened in 1906, the retailer did not survive past the end of the decade. Founder Mayer Israel was the nephew of the illustrious Leon Godchaux, whose namesake department store was also a Canal Street fixture.

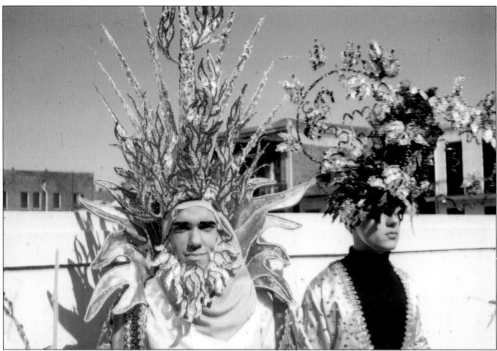

Ruth went for a close-up to capture the intricate filigree on these 1958 fantasy outfits. While many Mardi Gras masquers ventured to special Bourbon Street boutiques in search of the most striking physical decorations, most New Orleanians had but to consult their local newspapers; costume-makers and vendors would take out numerous classified ads in the run-up to February, each promising the most amazing and original Carnival apparel either for sale or rent.

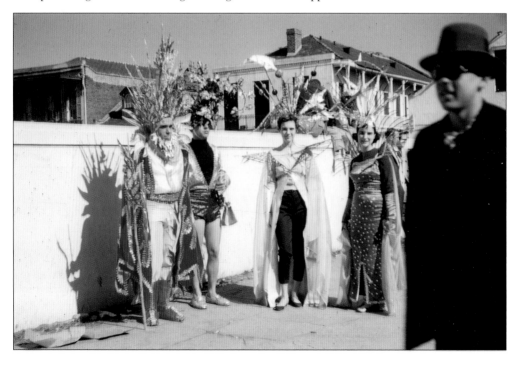

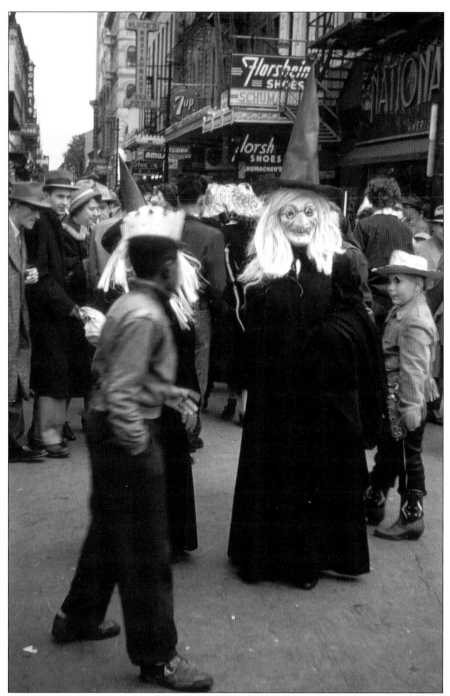

Cajun and French Quarter superstition abounds in stories about witches and ghosts, and here is a Halloween-like crone on Royal Street in 1952. An urban legend about Mardi Gras states that it is the birthday of the Devil Baby of Bourbon Street, a local demon woven out of a rich tapestry of area folklore. One claim is that on Fat Tuesday, one may encounter the imp on the streets in the form of a wizened old man. He is allowed to tell one's future if asked—at least until midnight, at which time the Devil Baby reverts to his true form: a wicked and hideous horned infant.

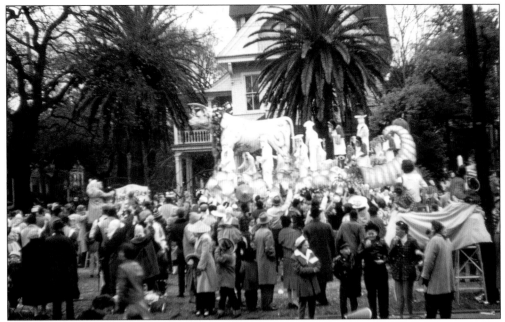

In 1960, on St. Charles Avenue in the Garden District, Ruth photographed a long-dormant Rex parade tradition that had just been reinstituted the previous year, the "Boef Gras," or fatted bull. Although it originally featured a live animal (representing the last red meat eaten by Catholics before Lent), the parading of the actual bovine was discontinued in 1909. But outsized papier-mâché float replicas like this one became popular all over again 50 years later and have remained prominent Mardi Gras symbols into the 21st century.

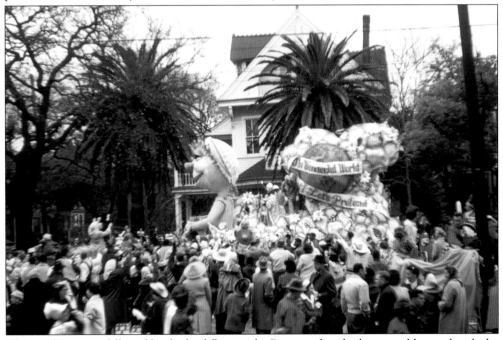

The Boef Gras was followed by the lead float in the Rex parade, which was emblazoned with the krewe's theme for 1960: "The Wonderful World of Let's Pretend."

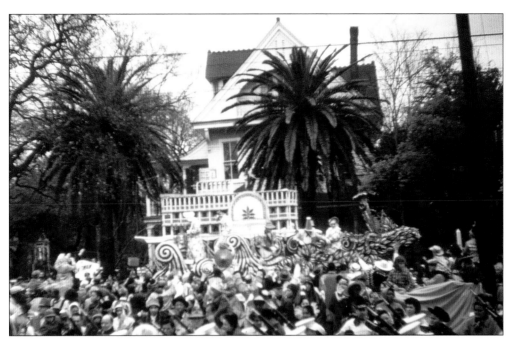

Where there is the Mississippi River, a paddle wheel riverboat cannot be far off. This land-going vessel, created in honor of author Mark Twain, appeared in the 1960 Rex parade. That same year, in that same St. Charles Avenue of the Garden District, Ruth photographed a young pair, a skunk, and a cowboy, standing amidst another historic mode of portage and transportation. The streetcar lines upon which these little spectators stand were part of the St. Charles line of the New Orleans Regional Transit Authority. The St. Charles line began operation in 1835 and was still functioning at the time of publication of this book (in 2019), constituting the oldest continuously operating streetcar route in the world.

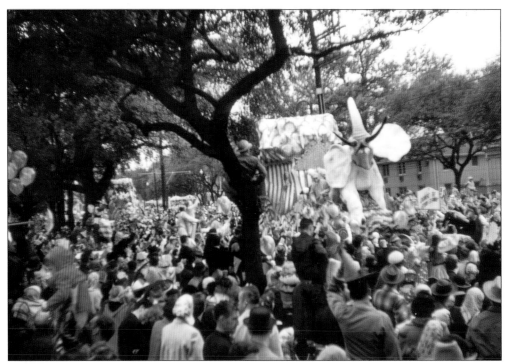

Although the original Walt Disney depiction of Dumbo the Flying Elephant had a slightly more grayish color scheme, he was a dazzling white elephant when he made an appearance in the Rex parade of 1960.

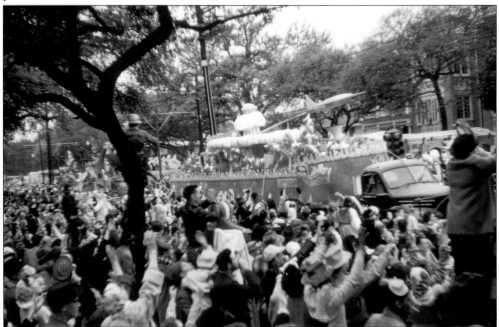

New Orleans may have had the nickname "the City that Care Forgot," but in 1960, the Cold War and nuclear jitters even entered into the Garden District's Mardi Gras pageantry, as this float entitled "Countdown" incorporates a jet plane and a mushroom cloud.

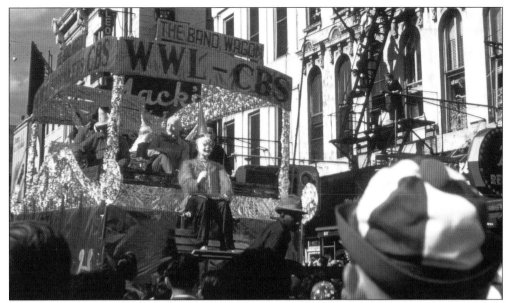

Before television became the undisputed king of the airwaves, New Orleans listened to WWL, an AM radio station distinguished from the 1950s to the 1960s by live broadcasts of Dixieland jazz artists. This 1950 Rex parade float promotes the CBS-network station, which can still be heard at 870 AM. In 1957, WWL-TV, also a CBS affiliate, began broadcasting. They would bring the sights and sounds of Mardi Gras to generations of viewers and listeners.

For many, the memories would remain in photographs, such as the ones taken by Ruth Ketcham, and in the hoarded beads, the treasured "throws," and the rare Zulu coconuts. To engage visitors for whom throws were not enough of a reminder of America's "greatest free show on Earth," a souvenir vendor maintains his pitch on Canal Street during the 1953 Mardi Gras. According to 2015 statistics, Carnival in New Orleans that year brought in more than 1.1 million visitors, with an average of $840 million spent.

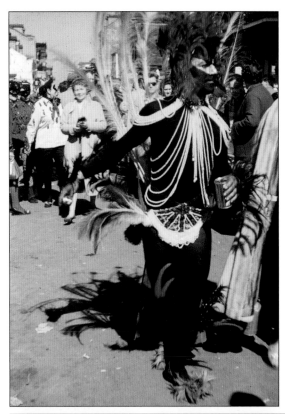

As Robert Tallant stated in 1947: "The really big show . . . when the parades appear in the streets of New Orleans, each to be followed by a huge ball, and then at last, at the climax, will be the big day, Mardi Gras, when all who wish may don costumes and masks and be anything they ever wanted to be and do *almost* anything they ever wanted to do."

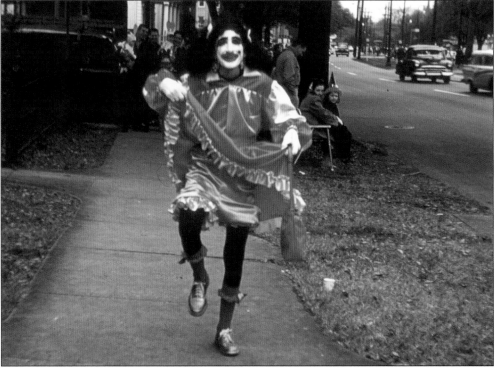

BIBLIOGRAPHY

Ambrose, Stephen, and Douglas Brinkley. *The Mississippi and the Making of a Nation*. Washington, DC: National Geographic Society, 2002

Anthony, Arthe A. *Picturing Black New Orleans: A Creole Photographer's View of the Early 20th Century*. Gainesville, FL: University Press of Florida, 2012.

Arthur, Stanley Clisby. *Old New Orleans: Walking Tours of the French Quarter*. Gretna, LA: Pelican Publishing, 1990.

Campanella, Richard. *Bourbon Street*. Baton Rouge, LA: Louisiana State University Press, 2014.

Cassady, Charles. *Crescent City Crimes*. Atglen, PA: Schiffer Publishing, 2017.

Chiri, Kevin. "Slidell man plays key role for 30 years in building Mardi Gras floats." *The Slidell Independent*, February 19, 2011.

Gessler, Diana Hollingsworth. *Very New Orleans*. Chapel Hill, NC: Algonquin Books of Chapel Hill, 2006.

Hardy, Arthur. "Lundi Gras riverfront celebration an old Mardi Gras tradition reignited in 1987." *The New Orleans Advocate*, February 8, 2016.

Hardy, Arthur. *Mardi Gras in New Orleans: An Illustrated History* (4th Edition), Mandeville, LA: Arthur Hardy Enterprises, 2014.

Karst, James. "The messy history of the po-boy." *Times-Picayune*, September 4, 2016.

Lait, Jack, and Lee Mortimer. *USA Confidential*. New York: Crown Publishers, 1952.

Long, Carolyn Morrow. "The Cracker Jack: A Hoodoo Drugstore in the "Cradle of Jazz."" *Louisiana Cultural Vistas*, Spring, 2014.

Maloney, Anne. "Alouette LeBlanc, 'America's Greatest Tassel Dancer,' dies."" *Times-Picayune*, April 8, 2009.

Patterson, Caroline Bennett. "Mardi Gras in New Orleans." *National Geographic*, November 1960.

Root, Cate. "Remembering the night the French Opera House burned." *Times-Picayune*, March 31, 2017.

Rowell, Galen. "Ode to Kodachrome." *Outdoor Photographer*, December 1999.

Tallant, Robert. *Mardi Gras . . . As It Was*. Gretna, Louisiana: Pelican Publishing (reprint of 1948 edition).

Trillin, Calvin. "The Zulus." *The New Yorker*, June 20, 1964.

———. "On the Possibility of Houstonization." *The New Yorker*, February 17, 1975.

———. "New Orleans Unmasked." *The New Yorker*, February 2, 1998.

Zibart, Eve, and Bob Sehlinger. *The Unofficial Guide to New Orleans*. Foster City, CA: IDG Books, 2000.

DISCOVER THOUSANDS OF LOCAL HISTORY BOOKS
FEATURING MILLIONS OF VINTAGE IMAGES

Arcadia Publishing, the leading local history publisher in the United States, is committed to making history accessible and meaningful through publishing books that celebrate and preserve the heritage of America's people and places.

Find more books like this at
www.arcadiapublishing.com

Search for your hometown history, your old stomping grounds, and even your favorite sports team.